PRESENTS

HOW TO DRAW

DIVERSE MANGA

Design and Create Anime and Manga Characters with Diverse Identities of Race, Ethnicity, and Gender

ROCKPORT

INTRODUCTION

Introduction to Saturday AM 4
Why Does Diversity in Manga Matter? 6

CREATING YOUR MANGA CHARACTER

PART ONE:

HEAD

Head Shape (Seinen) 13
Lips 18
Nose 21
BONUS! Black Nose and Mouth 24
Anime Eyes 26
Finishing Touches 28
Facial Expressions 30
Different Angles 33
Dynamic Expressions 38
BONUS! Guess The Style 42

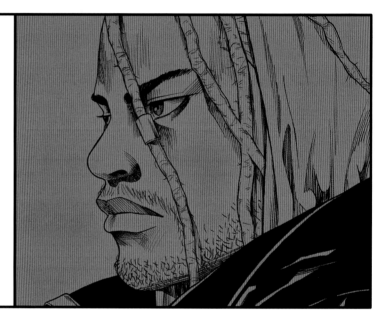

PART TWO:

HAIR

Afro 44
Afro: Stylish 46
Afro: Waves 48
Afro: Hair Part 50
BONUS! Part Variety 52
Bald & Balding 55
Braids 58
Detailed Braids 60
Dreadlocks 62
BONUS! Tips for Black Hair 65
Facial Hair 66
Straight Hair: Bangs 70
Straight Hair: Long 72
Straight Hair: Buns 74
Straight Hair: Two Block 78

PART THREE:

BODY

Body Proportions	82
Constructing a Body	84
Diverse Body Types	88
Hands	94
Feet	95

PART FOUR:

CHARACTER DESIGN: THEORY

Semiotics	98
Shape Language	100
Silhouette Test	101
Skin Tones	102

PART FIVE:

CHARACTER DESIGN: GALLERY

Creating Saturday AM Characters	104
Creating New Characters	116

PART SIX:

TOOLS & MORE

Art Tools: Traditional	129
Art Tools: Digital	131
Work Spaces	131

EXTRAS

Glossary	138
Acknowledgments	139
Credits	140
Resources	141
Index	142

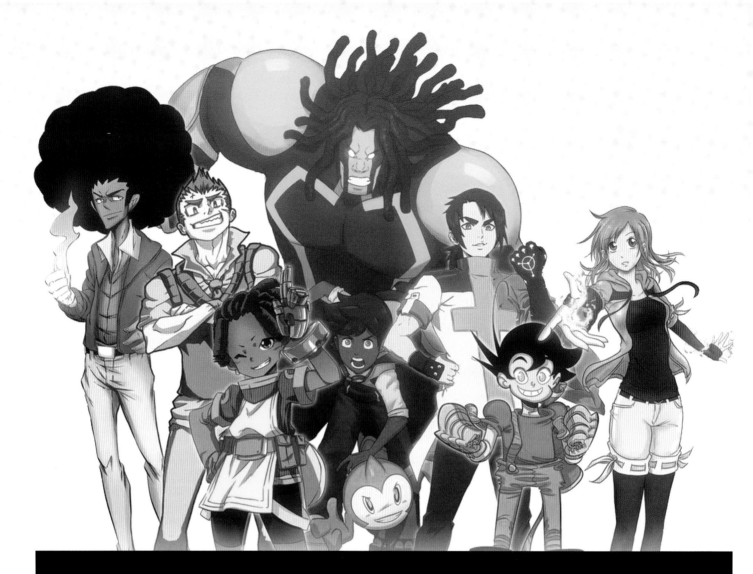

INTRODUCTION TO SATURDAY AM

Japanese MANGA and ANIME have inspired people worldwide for generations, but only in the past 20 years have they become a global phenomenon. Streaming services, cable TV, and increased digital distribution of both artists and their manga have inspired more people than ever. What began as, and still is, a predominantly JAPANESE cultural product now has practitioners and hobbyists from North and South America, Europe, Asia, and Africa.

Unfortunately, three things have become apparent:

- The vast majority of people will never live in Japan.
- Few people will learn to speak Japanese.
- The platforms in Japan do not showcase as many non-Japanese manga-style works as exist online.

Saturday AM hopes to be the bridge for those of us who LOVE MANGA but want MORE DIVERSE versions of it presented with the same love and care the Japanese comics receive.

Saturday AM is not a platform but a magazine and culture brand. Here EVERY TALENTED ARTIST OF ANY RACE, GENDER, or NATIONALITY can create their series for serious fans. The digital magazine launched in 2013 as a biweekly publication geared towards shōnen/shōjo manga (i.e., teenage readers— a.k.a. most Marvel Comics) and quickly grew a fandom that now encompasses over 60 countries. Likewise, our exclusive creators hail from six continents, with the most popular including WHYT MANGA (NIGERIA, creator of APPLE BLACK), SENY MANGAWORKS (HUNGARY, creator of SAIGAMI), and GLADISKSTUDIO (FRANCE/NIGER, artist of CLOCK STRIKER).

More than three dozen artists are working exclusively within our brand, such as Saturday PM (seinen, a.k.a. older teen male readers) and Saturday BRUNCH (LGBTQ and jōsei, a.k.a. older teen female readers). Furthermore, our brand has grown into COLLECTIBLE TOYS, MOBILE GAMES, PRINT GRAPHIC NOVELS, and APPAREL.

Since the beginning, Saturday AM has championed DIVERSE MANGA and the promise that more artists bringing their unique visions to the world can help expand the idea of manga-inspired comics.

We hope this book helps you create your MANGA-style CHARACTER with the confidence that there is an audience for authentic stories about heroes of all backgrounds.

FREDERICK L. JONES
Publisher, Saturday AM

WHY DOES DIVERSITY IN MANGA MATTER?

I first got into Japanese pop culture and anime in the late 1970s with STAR BLAZERS (the American version of Japan's iconic SPACE BATTLESHIP YAMATO). Instantly, I knew that the art style, character design, and mature stories were LIGHT-YEARS beyond the American Saturday-morning cartoons I was watching. In the '80's, my love of this material extended to GUNDAM model kits,

copies of the Japanese weekly SHŌNEN JUMP manga magazine (courtesy of a Japanese American family friend), and ROBOTECH. The last one (primarily based on the legendary Japanese anime SUPER DIMENSION FORTRESS MACROSS) cemented my lifelong fascination with anime and manga. By now, I was old enough to truly appreciate the depth of the stories with their

human drama better than any American daytime soap opera—while getting the visceral kick of seeing fighter jets transform into monster-sized robots. I would actively lobby friends and family to check out the series, which was not some mere "kids show" but a bona fide spectacle.

Some appreciated it. Others didn't. But, as I quickly realized, my friends who, like me, were African American, could all agree the character of CLAUDIA GRANT (née CLAUDIA LASALLE in the Japanese version) was special. We had never seen a Black woman in a cartoon with such agency. She was strong, intelligent, and a LEADER. She was in a healthy and mature interracial relationship while having a darker skin complexion than other anime characters and sporting a natural afro. In most anime, then and now, most "Black" characters are ambiguous, with no noticeable features to suggest they have any connection to the large African diaspora of our world.

The diversity of ROBOTECH was genuinely significant in my early support of the material and has driven my love affair with it for over 30 years!

Some might suggest that a conversation about diversity

in pop culture is "complicated" or even "controversial," but we won't be doing that here.

Diversity is neither complicated nor controversial. It's simply TRUTH.

In our world of over 7 billion people, there are over 5,000 ethnic groups. By 2050, the world will be 1/4 African by population. Of the total population, there are equal numbers of men and women. If entertainment reflected the world accurately, most entertainment would feature a large, diverse cast as the norm.

Again, it's odd for something as natural as diversity to be mischaracterized as "political." So, we're not going to do that.

Instead, we'd rather touch on the IMPLICATIONS of a lack of diversity.

Kids emulate what they see. Their perceptions of the world are shaped by how the media presents it. When kids do not see themselves in media, they begin to believe that it is normal that they are not central figures in stories. This attitude can affect their SELF-ESTEEM but also can cause a CALLOUS disregard of others. Prejudice stems from ignorance, and ignorance grows in the absence of representation.

A LACK of representation is not natural; it's a choice. Good stories are just as exciting whether the protagonist is a man or a woman, disabled or nondisabled, any ethnicity or nationality, gay or straight, liberal or conservative. Saturday AM chooses to tell inclusive stories to present more relatable fantasy worlds and inspire future empathetic stories from the next generation of creators.

We love comic books, and we REALLY LOVE Japanese comic books, a.k.a. manga. Many anime are adaptations of manga, and thus the representation in one affects the other. There is incredible diversity in

yet very few popular manga feature such familiar characters. And the desire to "fit in" finds many non-Japanese creators creating characters who are supposed to be Japanese despite a lack of knowledge or research about Japan, its people, and its customs.

Furthermore, there is a strange mental gymnastics that people go through to justify characters being "Black or of another minority despite not even looking as such. In one of the more infamous cases, many Black anime fans have related to PICCOLO of DRAGON BALL fame as "Black He is green, has antennae, and comes from an alien world called Namek. But when you are not used to seeing positive portrayals of your own race in popular content, any character out of the norm becomes someone you feel connected with.

Meanwhile, Black and brown cosplayers have often been insulted and harassed for daring to dress as their favorite characters. And some of SAILOR MOON DTIYs ("draw this in your style") brought negative responses due to artists choosing to represent their vision of Usagi (a.k.a. Serena in the English-language version) as a POC rather than a white or Asian character. While rare, Saturday AM has had some insults and online harassment directed at us since we launched, from people who seem threatened by the notion that we are creating original manga-style characters of color.

Evidently, some people who claim that manga has no problem with diversity do not like diverse people supporting it. Sadly, this behavior leaves fans of color feeling left on the outside looking in; free to spend money in the industry but not to partake in it as active participants.

We have heard that many Japanese manga-ka would like to have more ethnically diverse casts for their series. This desire, however, is countered by a fear that poorly illustrating these characters would be embarrassing and cause unhappiness, so they choose not to. We COMPLETELY appreciate this sentiment — drawing curly hair or accurately representing identifiable ethnic or cultural features

genre, character designs, and concepts but not so much in the types of characters. While Japanese and white Europeans are prominent characters, other ethnicities, including Southeast Asian, are not featured in many manga series. This lack of representation begins to have consequences with an increasingly global fanbase. Manga and anime are incredibly popular right now. According to the Association of Japanese Animations, over 87.2 percent of the world has access to anime, be it through streaming, TV, or home media distribution. Likewise, manga is ubiquitous due to both illegal scanlations worldwide and more official licensing or digital access becoming available.

When we started Saturday AM, several creators of color didn't want to have a person of color as the main character of their manga because they thought it would be perceived as "forced" despite being their lived experience. Again, it's not seen as unnatural when white characters appear in Japanese-set environments and story lines.

Naomi Osaka, Rui Hachimura, and Ariana Miyamoto are globally prominent half-Black, half-Japanese figures,

instead of making stereotypical imagery is work one must do CAREFULLY and RESPECTFULLY.

While being able to identify with those different from us is a good thing, it's equally important to see characters who are considered heroic, beautiful, strong, intelligent, and courageous from ALL backgrounds. EVERYONE benefits from this, as new types of stories can emerge as well as more vibrant fandom.

For Saturday AM, the answer to "Why does diversity matter?" is simple: WE LIVE IN A BEAUTIFUL, DIVERSE WORLD, and it MATTERS that we present the same BEAUTY in our IMAGINARY STORIES.

It's morally the right thing to do, it's ethically the right thing to do, and financially it's rather rewarding as well. It shouldn't be shocking that many people who enjoy manga would also LOVE to see themselves represented in their favorite art form. There are many small groups and creators online who post their unique takes across social media. (Seriously, look up #blackmanga and see the beautiful ideas that creators are presenting.)

In summation, we created this book, SATURDAY AM PRESENTS HOW TO DRAW DIVERSE MANGA, for you. It exists for ALL of those who LOVE manga. We believe it can serve as a small step in the right direction for the continued evolution of manga and manga-inspired stories.

FREDERICK L. JONES
Publisher, Saturday AM

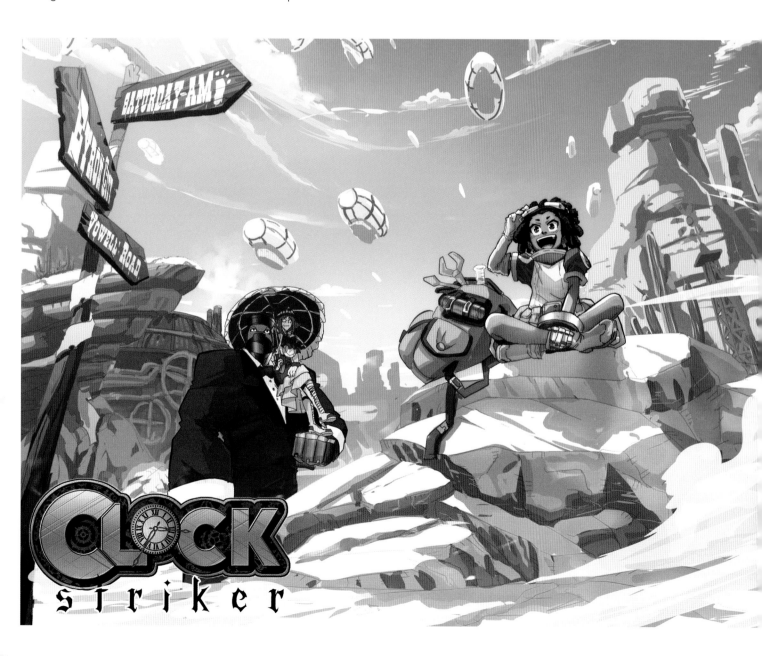

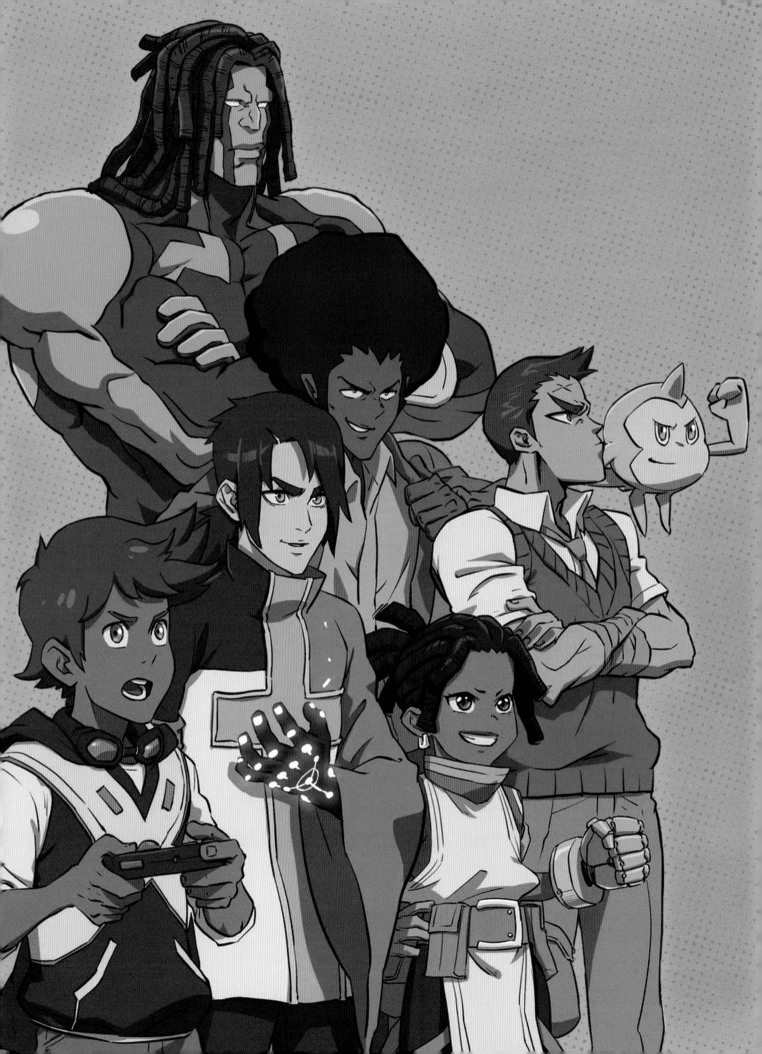

CREATING YOUR MANGA CHARACTER

PART ONE:

HEAD

THE MOST DISTINCTIVE ELEMENTS OF ANY CHARACTER DESIGN ARE ON THE HEAD. FEATURES LIKE EXAGGERATED NOSES, BIG LIPS, AND CROOKED EYES ARE OFTEN USED IN A COMICAL CONTEXT BUT CAN SOMETIMES PAINT A NEGATIVE IMPRESSION OF MINORITY POPULATIONS.

THIS SECTION INTRODUCES THE BEGINNING METHODS TO HELP CONSTRUCT YOUR OWN DISTINCTIVE AND RESPONSIBLE CHARACTER DESIGNS FOR HEROES, VILLAINS, OR SUPPORTING CAST MEMBERS.

HEAD SHAPE

LET'S BEGIN WITH A MORE REALISTIC STYLE, AKIN TO SOME TRADITIONALLY USED ART IN SEINEN MANGA OR WESTERN COMICS. NOT ONLY DO MANGA GREATS LIKE TAKEHIKO INOUE (REAL, VAGABOND) AND NAOKI URASAWA (MONSTER, 20TH CENTURY BOYS) OPERATE IN THIS STYLE, BUT THEIR WORKS PROVIDE INCREDIBLE CLARITY TO A MATURE SUBJECT MATTER.

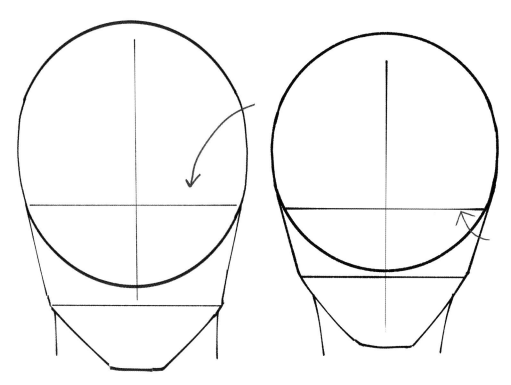

Eyes and ears generally fall around the center of the head vertically. This line shows about where that would be in this example.

1

The first step is to find the approximate head shape you want to create. Draw a circle for the head and an inverted trapezoid for the jaw.

Note:
By changing the shape of the trapezoid, defining the jaw, and playing with the distance between it and the circle, you can make a variety of head shapes. Experiment with this technique to create different faces.

2

Using the basic head shape as a template, draw the planes of the face. This will act like a template as we advance, so it can be as rough or as clean as you want.

This is also where you can begin establishing more unique characteristics, such as fuller lips or a flatter bridge for the character's nose.

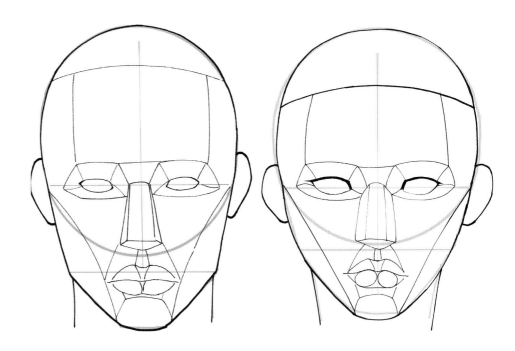

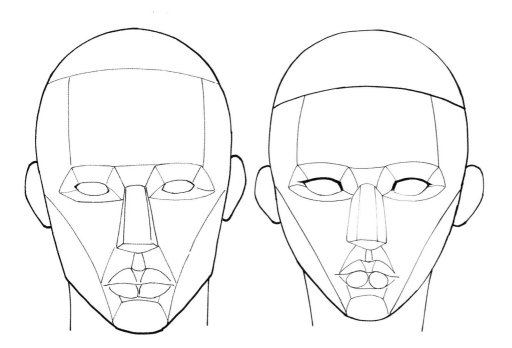

The distance between the eyes is generally about the width of another eye. You can vary this, but it's a good starting point.

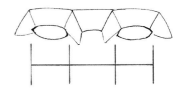

The sides of the nose generally line up with the inner corners of the eyes.

3

Now start filling in the details over your template. At this stage, you'll also make decisions about a character's unique parallel creases on eyelids, scar, and the empty left iris that suggests a damaged eye.

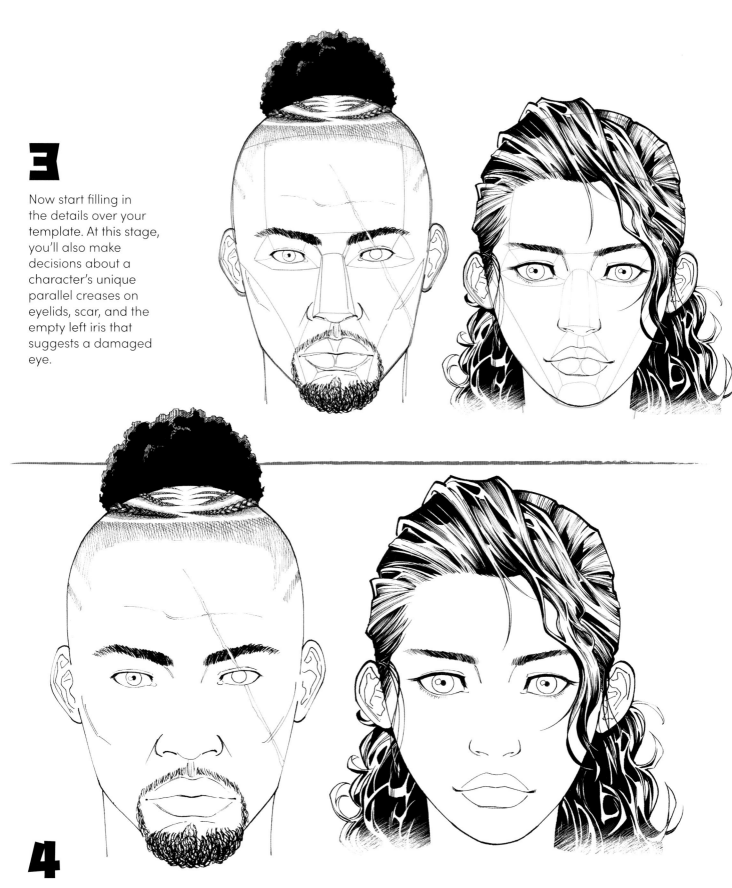

4

You could consider your character complete at this point, but you could add a bit more detail so it includes the aesthetic often seen in a seinen manga.

5

Add crosshatching to define features further and add depth to the final piece. Notice how the areas with the most hatching follow the planes made in previous steps.

The male character should appear to be around the age of 40. For a younger character, apply less hatching in the areas around the cheeks, the nose, and under the eyes to make the skin appear plump.

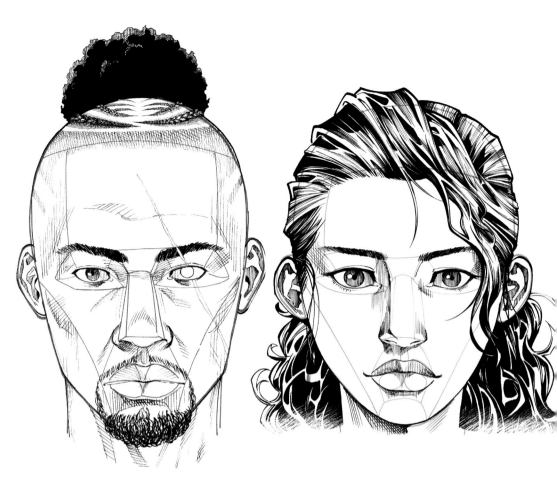

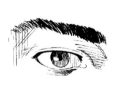

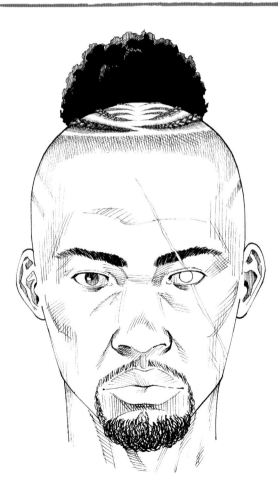

6

The darker the hatching, the deeper the shape you carve for particular features. Common areas for heavy shading are between the eyes, on the top of the nose, and underneath the nose and the bottom lip.

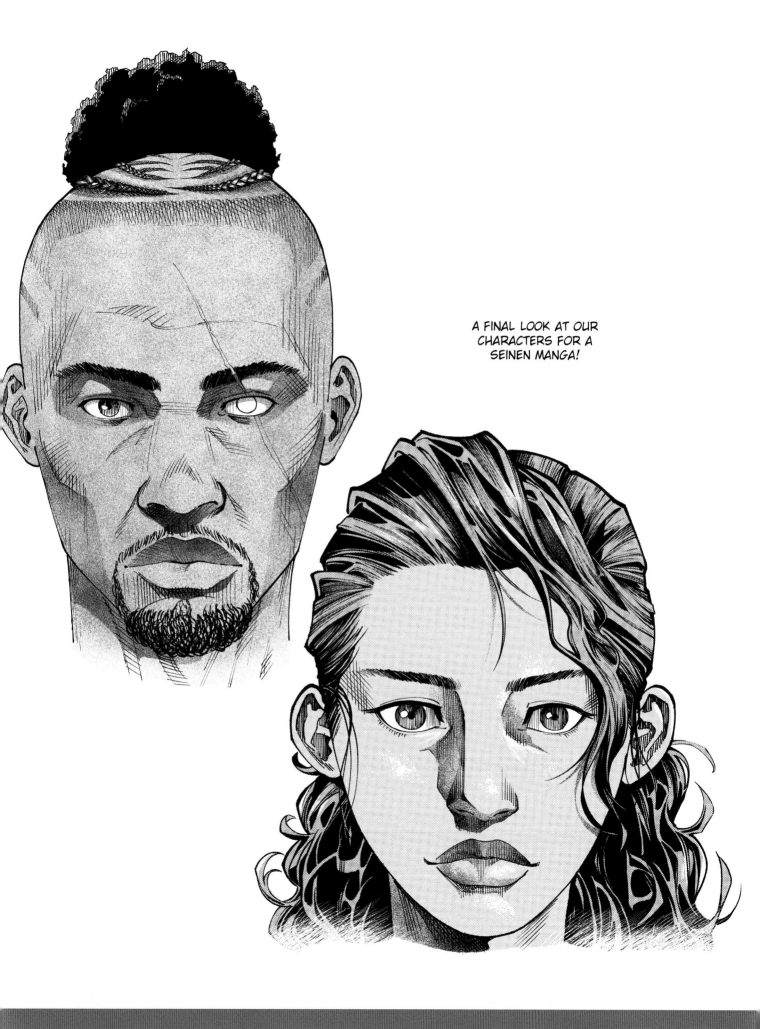

A FINAL LOOK AT OUR CHARACTERS FOR A SEINEN MANGA!

LIPS

FULLER LIPS CAN BE CHALLENGING TO DRAW WELL, DUE TO THE MEDIA'S PROBLEMATIC DEPICTIONS OF BLACK PEOPLE. IN THIS TUTORIAL, WE TAKE YOU THROUGH HOW TO ILLUSTRATE FULL LIPS TO ACKNOWLEDGE A CHARACTER'S ETHNIC FEATURES IN A WAY THAT AVOIDS BEING INSENSITIVE OR MEAN-SPIRITED.

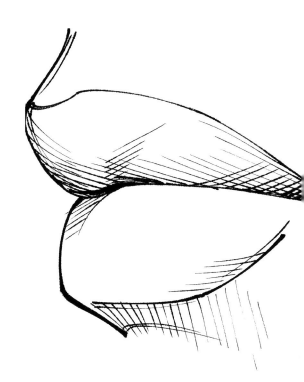

REALISTIC LIPS

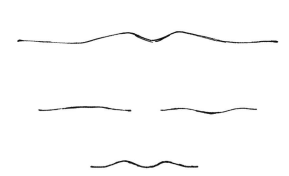

1

Start by drawing the line where the lips meet.

You can use the vertical line defining the center of the head to help position the mouth properly. You can also add an indentation in the middle of the line to add some extra depth.

2

Mouths can be of different shapes and sizes.

You can use a variety of line shapes for a diverse cast of characters.

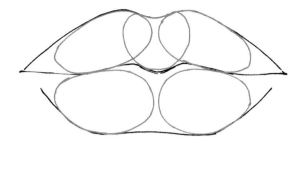

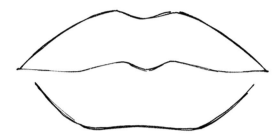

Now lay down the top and bottom lips. Think of lip shapes as two ovals facing each other with a heart shape in the center of the top lip.

Again, we can experiment with these shapes to create a variety of mouth shapes.

4

The same idea works for a side view of the lips. The difference here is that we are only seeing half of the shapes.

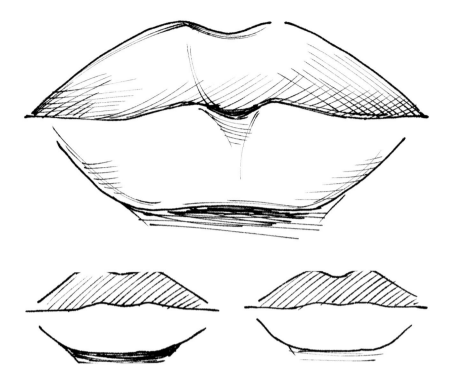

To finish, add shading through crosshatching.

The areas to hatch most prominently are the corners of the top lip and the area directly under the bottom lip.

The heavier the shading under the lips, the thicker the lips will appear.

Shading a side view follows the same process.

Focus on the corners of the top lip and the area beneath the bottom lip to add volume.

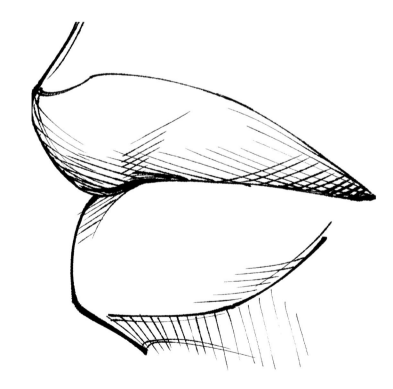

NOSE

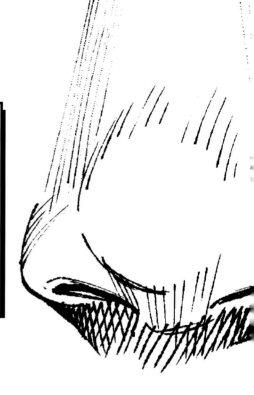

NOSES CAN ALSO BE CHALLENGING TO DRAW. OFTEN, ARTISTS WILL GIVE A CHARACTER AN EXAGGERATED NOSE TO DIFFERENTIATE THEM FROM OTHERS WHILE ALSO PROJECTING A TRAIT. FOR EXAMPLE, BIG NOSES HAVE BEEN USED TO SUGGEST THE PERSON IS "UGLY" OR "EVIL."

HOWEVER, DRAWING SEVERAL DIFFERENT NOSE SHAPES CAN HELP GIVE YOUR CHARACTERS A UNIQUE ENSEMBLE LOOK. AS SOME NOSE SHAPES ARE SIMILAR AMONG CERTAIN ETHNIC GROUPS, IT IS VITAL TO ILLUSTRATE THEM AUTHENTICALLY TO RESPECT YOUR CHARACTERS' BACKGROUNDS WITHOUT STEREOTYPING/CARICATURIZING.

1

As with other parts of the body, start by defining the nose with simple shapes. Here are the shapes to think about from the front view, ¾ view and side view.

2

Start building the form on top of these simple shapes.

The circles form the base of the nose and the lines coming down towards them create the bridge.

Like other parts of the body, playing with the shapes can change the look of the nose. Elongating the base, flaring the nostrils and widening the bridge are some examples.

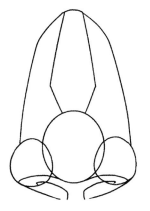

Here are some examples from the side view. Not only do different shapes change the overall look, but so does the position of those shapes. The base can drop to beneath the top of the nostrils. The bridge can be round or angular, or it can curve in different ways.

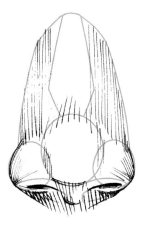
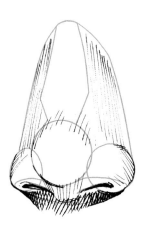
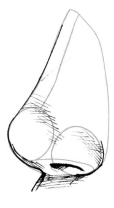

Now use the shapes as your guide to render the nose. You can use more rigid lines to define the nostrils and sides of the nostrils.

Hatching will help further define the shapes, like the side of the bridge and the rounds of the base. Often there will be a fair amount of shadow underneath the bottom of the nose.

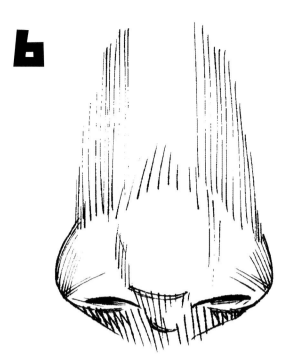

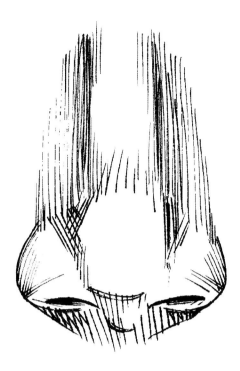

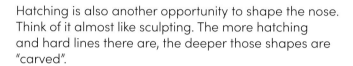

Hatching is also another opportunity to shape the nose. Think of it almost like sculpting. The more hatching and hard lines there are, the deeper those shapes are "carved".

Notice how the extra hatching makes the bride and nostrils more chiseled. Meanwhile, in the example above the nose appears more rounded and the bridge looks flatter.

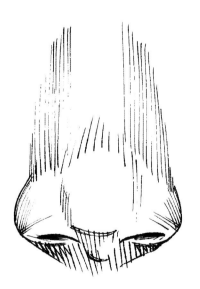

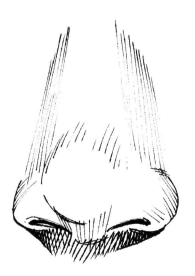

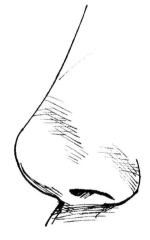

A final look at the nose rendered from those same three angles.

BONUS!

BLACK NOSE AND MOUTH

IN THIS SECTION, TWO OF OUR PROMINENT SATURDAY AM ARTISTS OFFER SOME ESSENTIAL ADVICE ON DRAWING BLACK NOSES AND MOUTHS.

There are so many different types of noses (and mouths) on Black and other darker-skinned people in real life, but popular media often uses the same type of unflattering depiction.

Stay away from the racially insensitive portrayals that not only are ahistorical, but age horribly as culture continues to evolve. For example, using overly big red caricature lips as a "natural" look for Black characters is incredibly insensitive for many reasons, including the racially insensitive context attached.

Characters who have lips like this in manga will rarely be the main hero, romantic lead, or hyperintelligent sidekick.

Thus, characters of color presented with these characteristics unfairly appear less capable than their lighter-skinned counterparts.

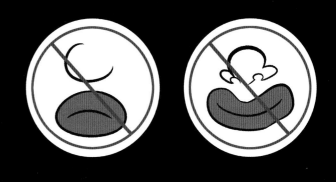

JEYODIN

My style is very cartoony and simple. I draw several different noses for Black people, but I think a few get the job done. I tend to make Black noses rounder than those of non-Black charaters, so instead of drawing a pointy nose like for my character Stud in the Saturday AM series HAMMER, I'll make it look more like a small button like Detective Dan, Stud's friend from the Ocean Kingdom.

If I want to make someone's nose more defined, I add two curved lines on the sides of the nose to indicate nostrils. This helps when I draw older characters especially.

When it comes to drawing a Black person's mouth and lips, I try to keep that simple. Usually, I'll draw a line for where the lips meet, and I'll draw a curved line above and below that to make the lips look more full. Another way of doing this is to draw the lips out entirely: draw the indent on the top lip and connect the lower lip line to each side of the mouth. I usually use this method when I draw women.

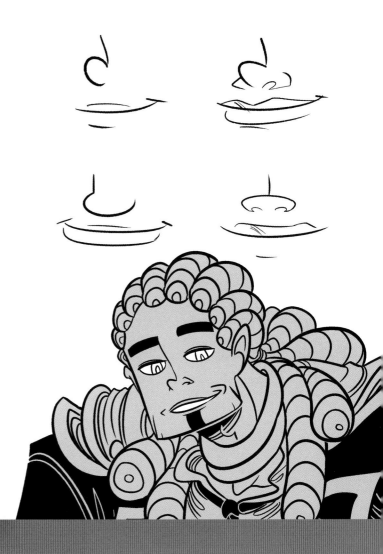

J.R. DE BARD

Yo! It's JR De Bard, creator of the Saturday PM title UNDERGROUND! The style I use for my martial arts sports manga series is less cartoony, and I use quite a bit of hatching to define the shapes of each character's features.

When it comes to noses, generally my Black characters have flatter bridges and wider nostrils. To illustrate this, I avoid using solid, thick lines to define where the nose ends and the cheek begins.

Instead, I'll use hatching to create gradation between the bridge of the nose and the cheeks. This helps keep the nose from looking angular. At the tip of the nose, I will also retain a round shape and draw wider nostrils.

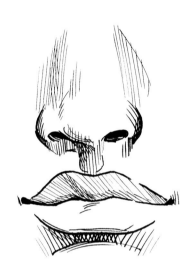

I use the eyes as a reference point for the nostrils: if I draw a straight line down from the inside corners of the eyes, I will generally have the nostrils come either right to or ever so slightly past this line.

If your character's nose is where their cheeks should be, you've gone too far.

Check out this example of Karim, the main character from my series.

I tend to draw my Black characters with rounder and more full lips as well. I start with the lines for where the upper and lower lips meet.

Following this, I define the shapes of the upper and lower lips, keeping the lines soft and round.

To finish up, I'll use some more hatching to show shadow on the top lip and directly underneath the lower lip. Again, it is essential with the lips to find that sweet spot and not exaggerate the size to an absurd degree.

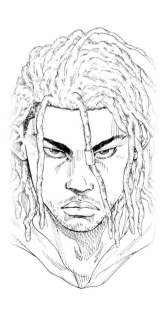

ANIME EYES

IN ANIME-INSPIRED ARTWORK, EYES ARE KNOWN FOR BEING BOTH HIGHLY STYLIZED AND VIBRANTLY EXPRESSIVE. BEGIN BY SKETCHING THE GENERAL SHAPE OF THE EYES. STYLIZED EYES TEND TO COME IN SIMPLE SHAPES AND SIZES. CHOOSE WHAT WORKS BEST FOR YOUR CHARACTER: SQUARISH OR RHOMBUS EYES TEND TO BE FOR RELIABLE CHARACTERS. CIRCULAR EYES TEND TO BE FOR MORE BUBBLY, SOFT, AND HARMLESS PERSONALITIES. MORE TRIANGULAR EYES TEND TO BE FOR THE MORE CUNNING TYPES. FEEL FREE TO MIX AND MATCH, FORM YOUR OWN SHAPES, AND BE CREATIVE.

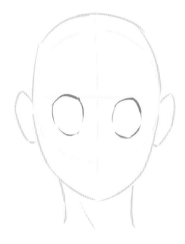 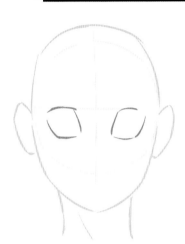 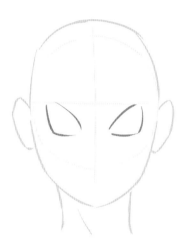

Make sure the distance between the eyes is as shown in the appropriate part of our initial circle split into four for the character's head shape. Usually, the eyes should not be too close to each other.

Apply the same concept when adding eyebrows to your sketch.

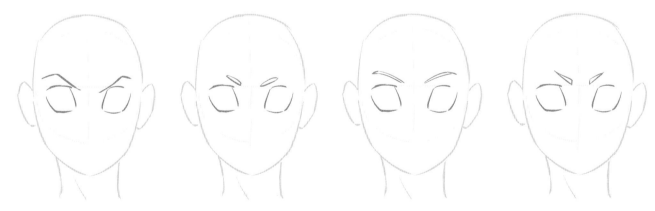

Like the eyes, place the eyebrows as shown; they normally are a little closer to each other than the eyes. Eyebrows can heavily dictate the types of facial expressions a character can have.

Add the iris and pupil. The same shape concepts may apply, but you can be even more creative if desired.

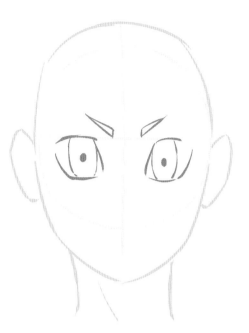

Certain art styles may depict some characters with solely pupils.

Add a light source hitting the eyes to help bring life to the overall sketch. Here are a few examples of using different shapes to execute the shine in the eyes.

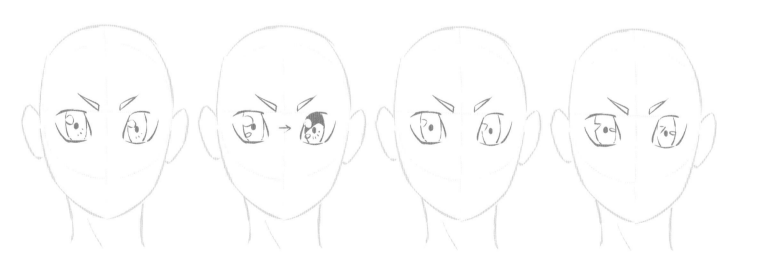

FINISHING TOUCHES

NOW IT'S TIME TO COMPLETE YOUR CHARACTER'S HEAD DESIGN. IN THIS SECTION, WE WILL DEMONSTRATE SOME FINISHING TOUCHES FOR YOU TO USE.

There are traditional differences between standard "male" and "female" head shapes. For instance, a female character usually has a thinner neck and a pointier jaw. Female lips may also be more defined, with lines for the upper and/or lower lips.

The lines for the upper and lower lashes on the eyes will generally be thicker on feminine characters. The upper lasher are usually thicker than the lower lashes, and the eyes may also include makeup.

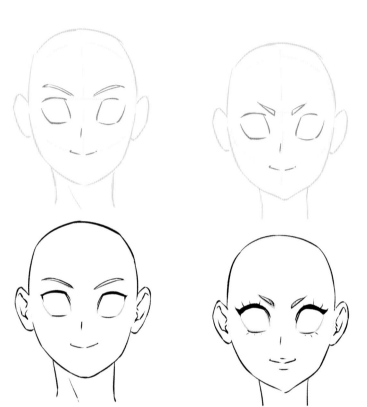

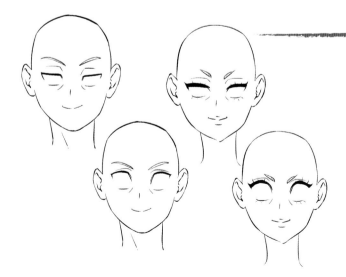

Optional:
Add lines to indicate upper or lower eyelids. Note that lines for lower eyelids tend to make a character look tired.

BONUS!

WHEN EYES ARE PARTIALLY OPEN, DRAW AT LEAST HALF OF THE PUPIL. HAVE FUN EXPERIMENTING – THE POSSIBILITIES ARE ENDLESS!

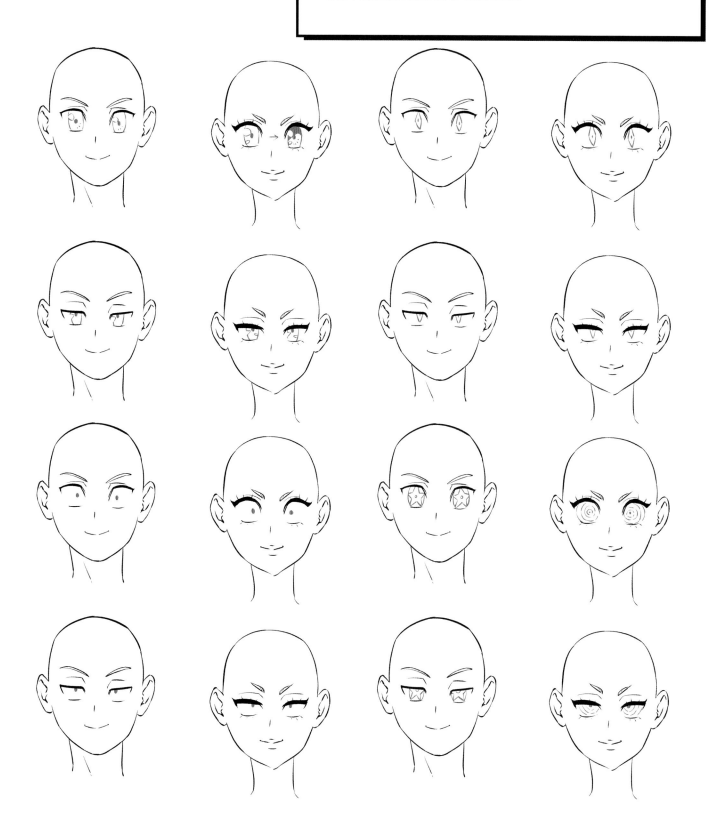

FACIAL EXPRESSIONS

AFTER LEARNING HOW TO DRAW A STANDARD HEAD AND FACE, THE NEXT STEP IS TO BRING YOUR CHARACTER TO LIFE WITH FACIAL EXPRESSIONS, ALLOWING VIEWERS TO INFER WHAT EMOTIONS YOUR CREATIONS ARE GOING THROUGH. MANY FACIAL FEATURES HELP CONVEY EMOTION, BUT THE EYES, EYEBROWS, AND MOUTH ARE THE MOST OBVIOUS.

HERE ARE SOME EXAMPLES OF SIMPLIFIED FACIAL EXPRESSIONS FOLLOWED BY CHARACTER ILLUSTRATIONS TO HELP DEMONSTRATE THE SIMPLICITY OF ADDING THESE EVERYDAY EMOTIONS - MAINLY THE EYEBROWS AND THE MOUTH. NOTE: ACHIEVE MORE EXPRESSIVE FACIAL EXPRESSIONS BY WIDENING BOTH A CHARACTER'S EYES AND THEIR MOUTH. REMEMBER TO PULL THE JAW DOWN SOME MORE THE WIDER THE CHARACTER OPENS THEIR MOUTH. SHOWING A CHARACTER'S TEETH CAN ALSO, IN SOME CASES, ACCENTUATE THE FACIAL EXPRESSION.

HAPPY

- When the mouth opens wide, the jaw is lowered.
- Even when the mouth is open, it still corresponds to the basic emotion , as in our simplistic versions.
- The more we see of the pupils and iris, the more accentuated the expression.

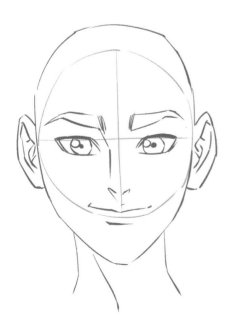
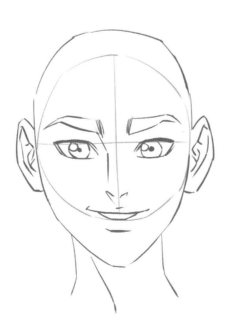
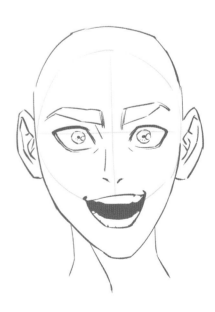

SAD

Note: In some styles, the pupil and iris are made smaller to convey heightened shock.

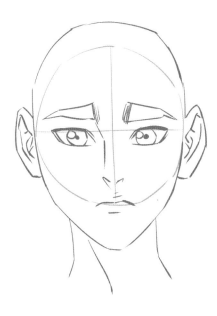 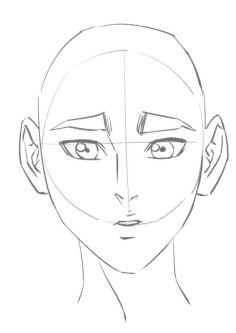 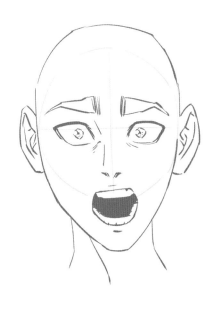

ANGRY

Note: Face wrinkle lines can also help accentuate the expression.

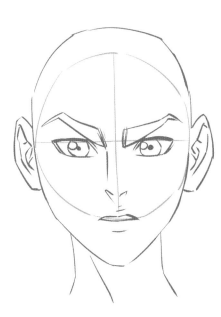 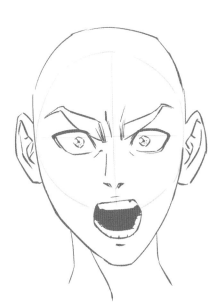 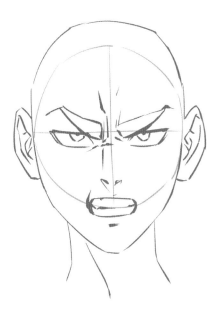

BONUS!

Mix and match eyebrow and mouth combinations to form other expressions with nuance. Believe in yourself and take the appropriate stylistic liberties where you see fit! Here are some examples.

The first face combines a shocked, angry-looking eye with a happy, wide mouth, giving the character a hyper, excited look. The second combines sad, tired eyes with the same a happy, wide mouth to create a creepy, uneasy, but relieved look on our character.

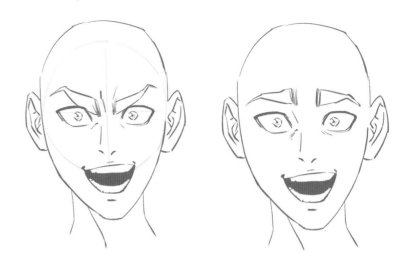

FACIAL FEATURE PLACEMENT

WHERE YOU PLACE THE EYES, NOSE, MOUTH, AND OTHER FACIAL FEATURES PLAYS A SIGNIFICANT ROLE IN YOUR CHARACTER'S APPEARANCE. THE PLACEMENT OF FACIAL FEATURES AND SHAPE, SIZE, AND TONE CAN MAKE A CHARACTER DISTINCT FROM OTHERS AND ALSO SIGNAL THEIR ETHNICITY. PROTRUDING EYES OR WHERE THE BRIDGE OF THE NOSE BEGINS CAN SIGNAL A LOT TO THE VIEWER.

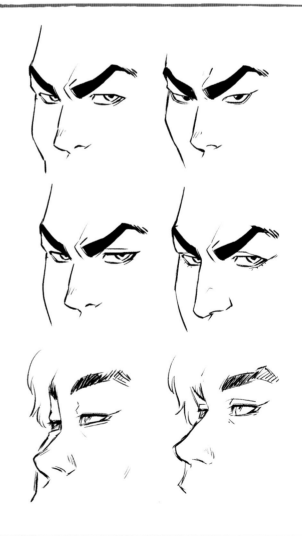

DIFFERENT ANGLES

TO FULLY GRASP HOW TO DRAW A FACE, PRACTICE ILLUSTRATING IT FROM DIFFERENT ANGLES. THIS SKILL SET WILL COME IN HANDY WHEN TRYING TO CREATE YOUR OWN MANGA-STYLE COMIC. HERE ARE TWO EASY, STRAIGHTFORWARD ANGLES TO LEARN FIRST.

SIDE VIEW

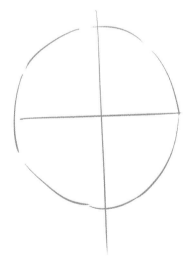

1

Draw a circle and split it into 4 parts.

Use this circle as a guide to add the jaw and the top of the head. These shapes may vary depending on the type of character you want to create.

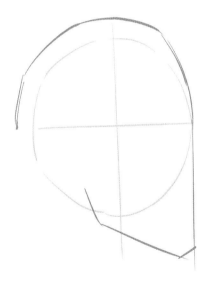

2

Use this circle as a guide to add the jaw and the top of the head. These shapes may vary, depending on the type of character you want to create.

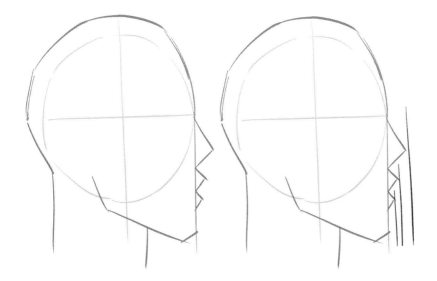
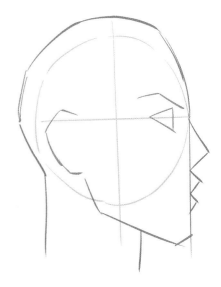

Add the nose and mouth. For a standard look, the nose should extend further than the upper lip, and the upper lip should extend further than the lower lip.

Draw two angled lines that meet at the center guide for the eyelids and a third line to connect them for the eyeball. Add an arched line above for the eyebrow.

TIPS:

- The placement of the pupil is not centered. Instead, it is traditionally set back a little.

- Even when the eyes are halfway open, part of the pupil is always visible.

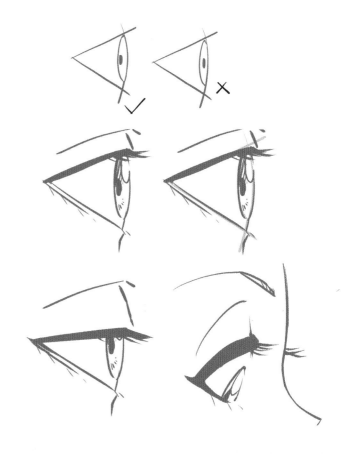

5 Use the guide you've just created to form your desired character.

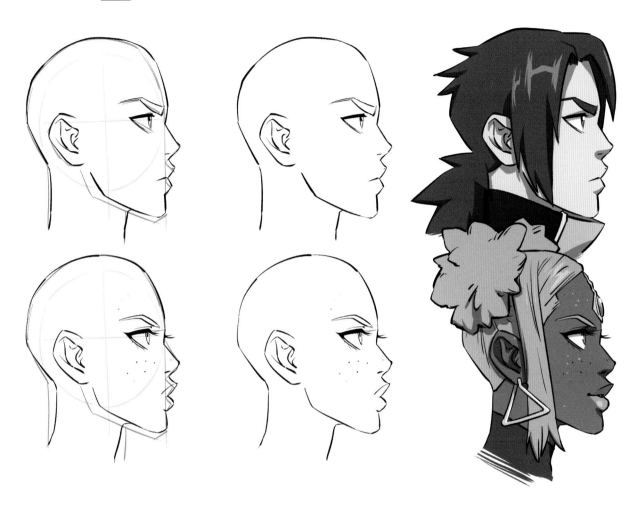

EXPERIMENT BY HAVING YOUR CHARACTERS LOOK IN DIFFERENT
DIRECTIONS AND BY USING DIFFERENT ART STYLES TO DRAW THE EYE.

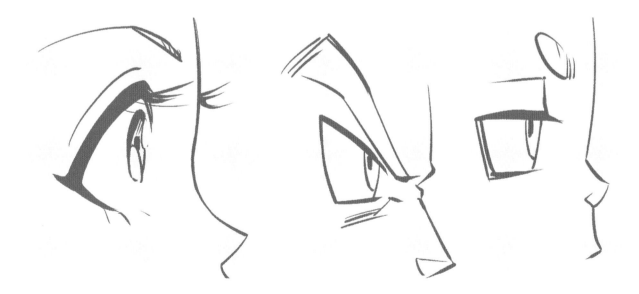

3/4 VIEW

1

Draw a circle and as with the side view divide it into four parts, but this time with curved lines to indicate the head facing the desired direction.

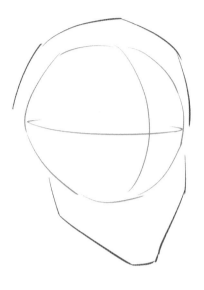

2

Use this circle as a guide to add a jaw and the top of the head.

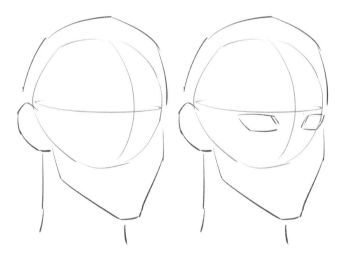

3

Add the ears, neck, and eyes using the techniques you have learned so far in this book. The eye farther from the viewer should be smaller and thinner due to perspective taking its course. **Note**: The lower end of the ears usually connects to the jawline.

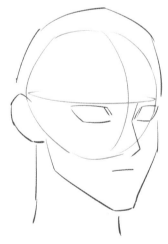

4

Add the nose and mouth. Make sure the nose is pointing in the appropriate direction.

5

Use the guide you've just created to form your desired character. The exact placements of these facial features is up to your discretion and art style.

But don't stop here! There are many more organic and dynamic angles to learn to bring your work to life!

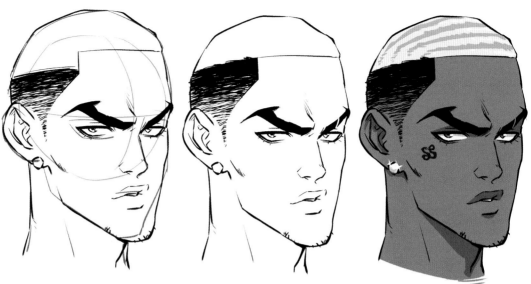

BONUS!
CAPTURING PERSONALITY

Facial expressions work best when they are accurate to the character. Cast is the star of Saturday AM's CLOCK STRIKER. As a disabled young girl, she has had to prove herself against various bullies; she refuses to let people think of her as weak, as she has immense pride. So even when she has emotional moments, she tries not to show it, and our artist, Issaka Galadima, draws her with strong eyebrows to convey this.

Another example is Shikamaru Nara of the hit manga NARUTO by Masashi Kishimoto. He is an only child with a strong-willed mother who has developed a quiet, contemplative disposition, deemed lazy by most of the other young chūnin ninja. As a result, it's rare to see him with exaggerated expressions even when he is excited. Always consider YOUR CHARACTER'S PERSONALITY when illustrating their facial expressions.

DYNAMIC EXPRESSIONS

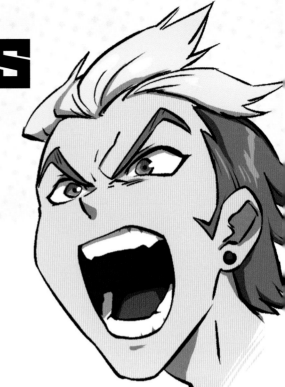

THE MORE DYNAMIC AND EXCITING THE ANGLE YOU DRAW
YOUR CHARACTER FROM, THE MORE ORGANIC AND LESS
STRAIGHTFORWARD IT LOOKS. THERE IS A TIME AND PLACE
FOR THE MORE PRECISE ANGLES, BUT TRY A SIMPLE
APPROACH TO DRAWING FACES WITH EXPRESSIVE MOUTHS
FROM DYNAMIC ANGLES.

IT CAN BE AS COMPLICATED AS YOU WANT - IT DEPENDS
ON YOUR ART STYLE - BUT IN THIS SECTION, WE'LL TRY TO
KEEP IT SIMPLE AND FUN FOR YOU!

LOWER ANGLE

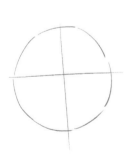 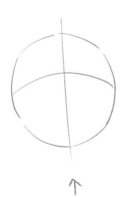 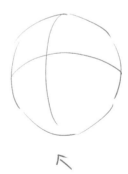 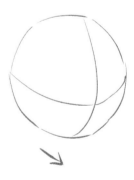

1

The circles you've been drawing so far have been grid-like guides sketched to assist you in the beginning stages of your face drawing. Notice that the position of the lines indicates where your character is facing and the angle you are drawing the character from.

Decide on the expression you want and come up with an angle using our crossed-circle guide approach.

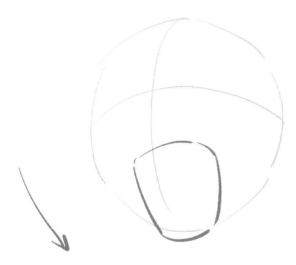

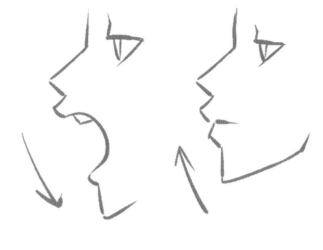

2

Draw a shape for the expressive mouth. It matters little what facial features you draw first as long as you know what's going on.

Note: The wider the mouth, the lower the jaw goes. The lower part of the mouth is subtly going further back—not just down.

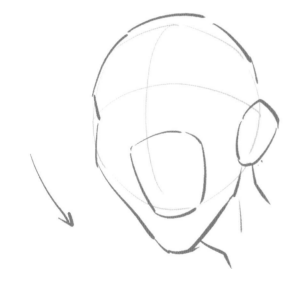

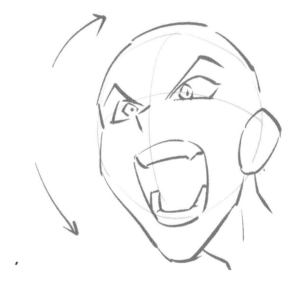

3

Add quick shapes for the head, ear(s), and neck as shown, continuing to use what you've learned so far. Because of the lower "camera" angle in this example, we see less of the forehead and the top of the head.

4

Add the eyes, eyebrows, and nose based on the desired expression. Depending on the angle you choose, certain facial features may partially or completely block other features. For example, in this illustration, the nose is partially blocking the character's right eye (our left).

Add teeth if necessary. We will see more or fewer teeth depending on the character, art style, expression, and angle we're drawing from.

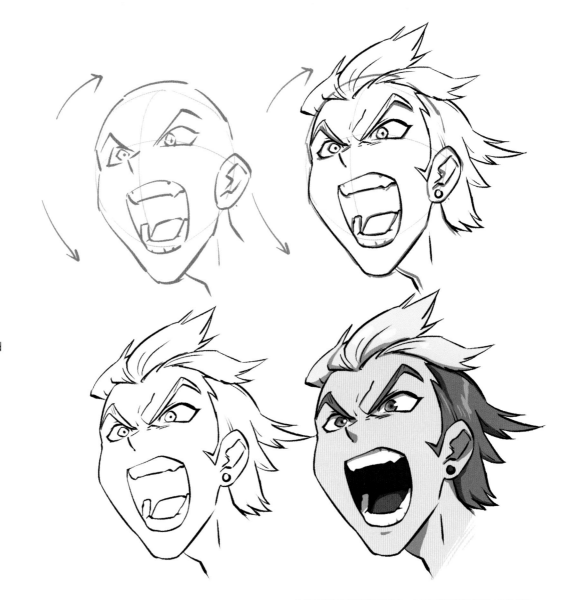

5

Add details and the remaining features to form your desired character!

NOTICE THE JAW DIFFERENCE

It's the same approach and angle, except here we started with eyes first. The jaw is not as low because the mouth is not as wide.

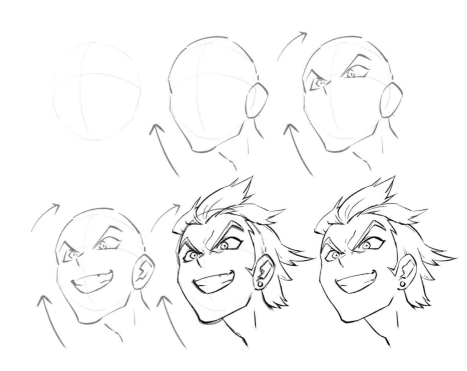

HIGHER ANGLE

From this angle, the nose does not block either of the eyes. Instead, the eyebrows can block the eyes, especially because of the expression here.

If you're unsure how low the jaw should be to accommodate space for the mouth, start by drawing the mouth before the other features.

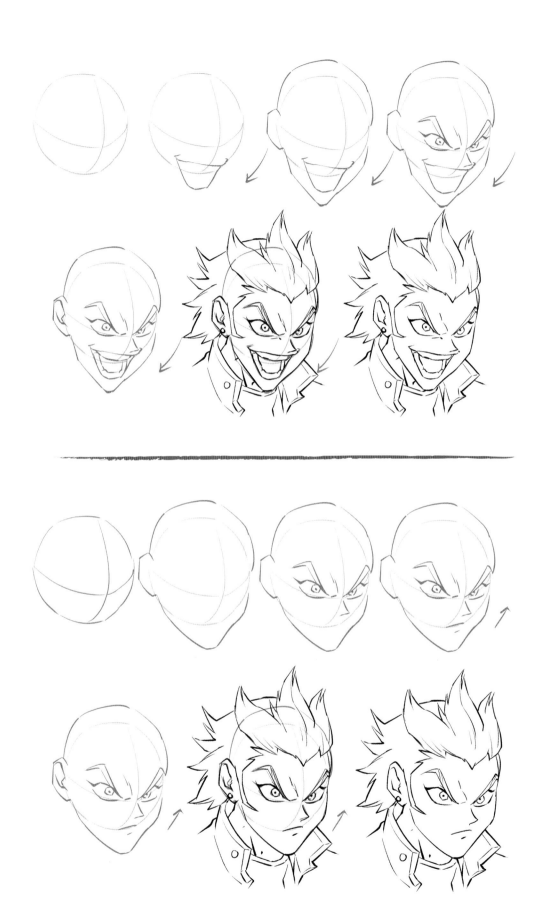

GUESS THE STYLE

DIVERSITY ALSO MEANS THAT ANY ART STYLE CAN WORK WHEN CREATING A CHARACTER. AS A FUN EXERCISE, LET'S CHECK OUT SOME DIFFERENT DEPICTIONS OF **SANO BENGOTE TAMASHII** AND **OPAL WANTMORE**, TWO OF THE CHARACTERS FROM **APPLE BLACK** BY **WHYT MANGA**. SEE WHETHER YOU CAN GUESS EACH OF THE POPULAR ANIMATED SERIES STYLES!

CHECK THE ANSWERS IN THE RESOURCES SECTION OF THIS BOOK.

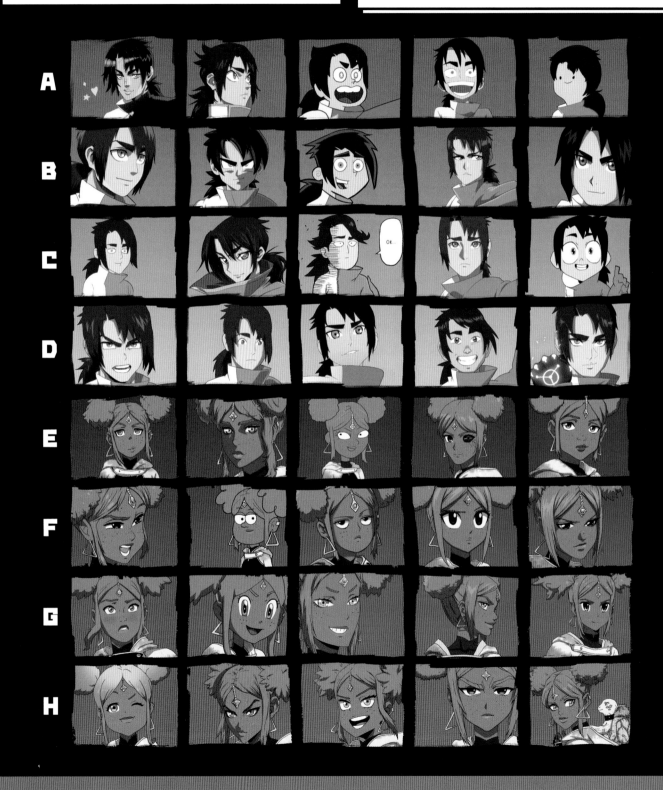

PART TWO:

HAIR

SOME OBSERVERS STILL DESCRIBE MANGA AND
ANIME ART STYLES AS "CARTOONS WITH SPIKY
HAIR AND BIG EYES." STATEMENTS LIKE THIS ARE
POOR DESCRIPTIONS, BUT THEY DO DEMONSTRATE
JUST HOW SIGNIFICANT THE HAIR HAS BECOME
TO THE AESTHETIC. THIS SECTION WILL EXPLORE
A VARIETY OF HAIRSTYLES THAT CAN BRING
ADDITIONAL DEPTH TO YOUR CHARACTER DESIGNS.

AFRO

THE AFRO IS ONE OF THE MOST COMPLEX ELEMENTS OF CHARACTER DESIGN, ESPECIALLY FOR BLACK CHARACTERS. WHILE INTERPRETATIONS ARE ALWAYS WELCOME IN ANY ARTISTIC EXPRESSION, THE IMPORTANCE OF THIS VISUAL TO BLACK CHARACTERS - AND FANS - IN PARTICULAR REWARDS ACCURACY WITH A MORE TRUSTED AND INCLUSIVE REPRESENTATION. THIS SECTION SHOWCASES SOME CLEVER TRICKS FOR NAILING THIS NATURAL HAIRSTYLE, WHICH IS COMMON PRIMARILY AMONG PEOPLE OF AFRICAN DESCENT BUT CAN BE SPORTED BY CHARACTERS OF MANY OTHER ETHNICITIES AS WELL.

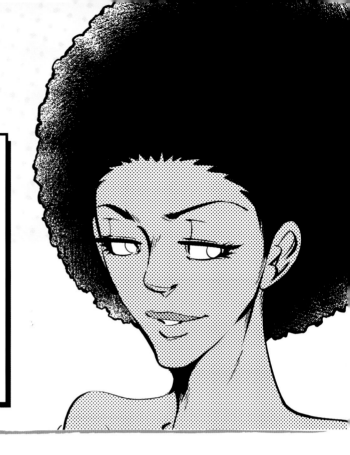

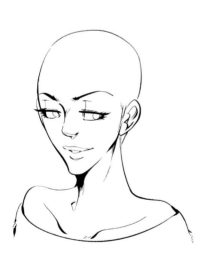

1

Start with the shape of your character's head.

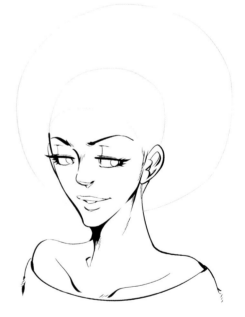

2

Create an elliptical "halo" around the head and define the hairline. Afros come in different shapes and sizes, but for a more realistic design, it's important to keep it proportional to the size of the character's head and off-center from front to back—it should appear to be above and behind the head.

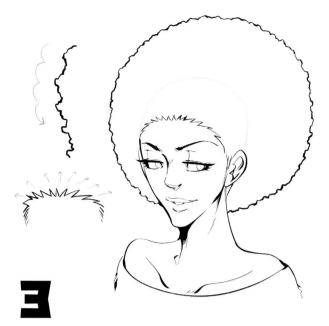

BONUS!

An Afro rendered with a cotton swab?!

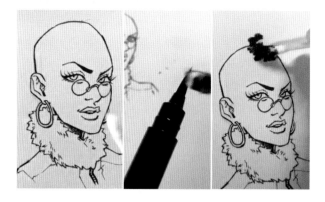

Dab a cotton swab in ink, then dab it onto your character.

3

Define the outside shape of the Afro by drawing a continuous but not completely straight line. You can imply a certain texture by using rounder or more jagged edges, depending on your preference.

Be sure to keep the overall peaks and valleys of this line tight along the "halo" guideline you created in the previous step. I use a zigzag line along the hairline, being sure to curve it around the head and back down to the tops of the ears.

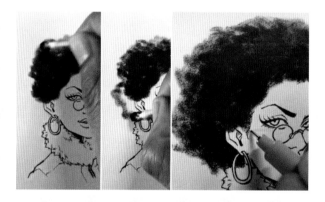

As the ink dries on the cotton swab use it for the edge of the Afro and then finalize the rendering with your inking pen.

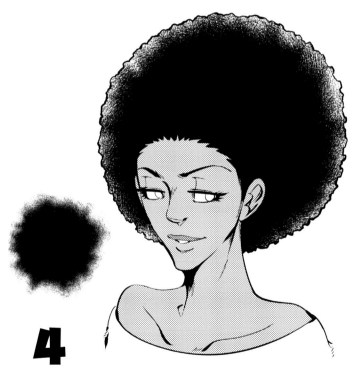

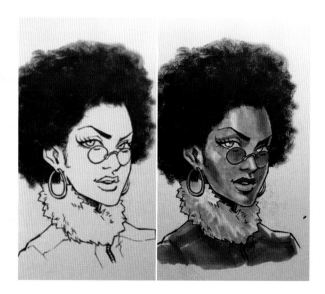

4

Fill in the hair. You can fill it in completely or use techniques like stippling (see Glossary), scribbling, or hatching along the edges of the Afro to give the impression of texture and depth.

Complete the character's head with alcohol-based markers.

AFRO: STYLISH

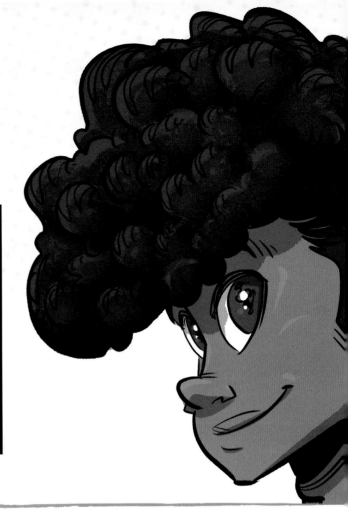

ICONS LIKE ANGELA DAVIS AND JIM KELLY POPULARIZED THE ROUND AFRO IN POP CULTURE IN THE '70S. THE LATE MUSIC LEGEND PRINCE POPULARIZED THE STYLIZED, RELAXED HAIRSTYLE THAT INSPIRED A NEW TYPE OF EXPRESSION FOR MEN, BLACK MEN IN PARTICULAR. WHILE NOT THE FIRST, LITTLE RICHARD CERTAINLY HAD A DRAMATIC LOOK. CHEMICALLY RELAXING, BLOWING OUT, AND DOING UP BLACK HAIR HAS BEEN A CREATIVE EFFORT BY DESIGNERS AND ARTISTS ALIKE.

HERE WE SHOW HOW TO CRAFT A STYLIZED AFRO.

1

Draw the head.

2

Draw several bumps, varying in size, and create the shape and the volume of the hair.

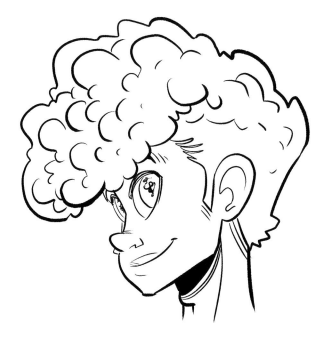

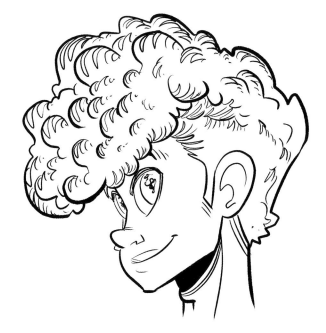

3

When drawing the hairline, have the front of the hair hang over the forehead, and draw the hairline under that.

4

Add detail to make the inside of the hair shape look bumpy.

5

Color the image and then use the stippling technique to add shadow to create another layer of depth. Whether you color it digitally or traditionally, all you have to do is make sure the parts of the hair lit by a light source have little to no stippling on them because they are casting the shadow onto other parts of the hair. Try heavily saturating those parts with a stippling shadow, thus demonstrating that the hair has texture and body. To add a highlighting effect, use the same effect on the hair features you want highlighted to make it look even more textured.

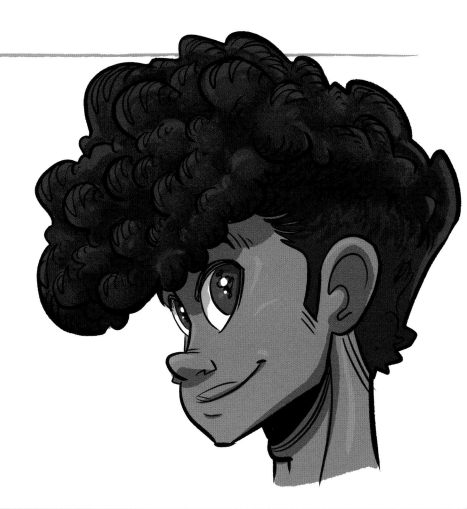

AFRO: WAVES

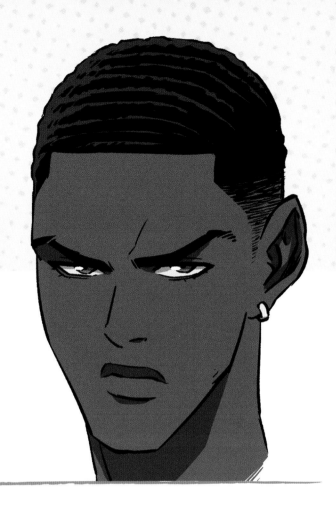

WAVES ARE A VERY UNCOMMON HAIRSTYLE IN HOW-TO-DRAW BOOKS ANYWHERE DESPITE THEIR POPULARITY AMONG THOSE WITH SHORT, CURLY HAIR. THE HAIR STRUCTURE IS SIMILAR TO THAT OF WAVES IN THE OCEAN, HENCE THE NAME. WHEN CREATING THIS RIPPLE-LIKE PATTERN, CONSIDER HOW A LIGHT SOURCE REFLECTS ON THE HEAD AND MAKE SURE YOU HAVE A STRONG UNDERSTANDING OF WHERE THE LIGHT IS COMING FROM IN YOUR ILLUSTRATION. IN THIS EXAMPLE, THE LIGHT SOURCE IS ON THE TOP LEFT.

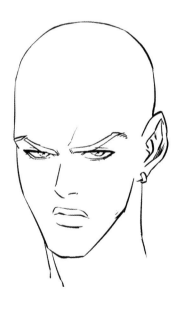

1

Establish the hairline of your character. You can use references from real life to see vast variety of different hairlines that exist.

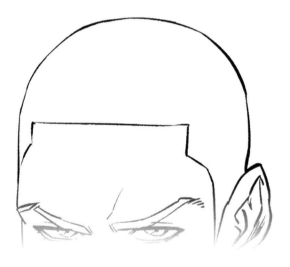

2

Establish the light source. That will determine where the light hits the waves and make them visible. Here, our light source is coming from the top left.

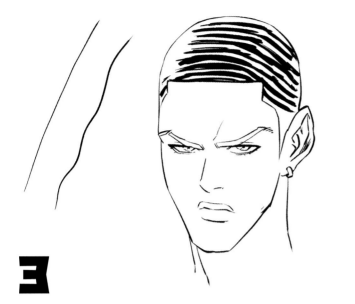

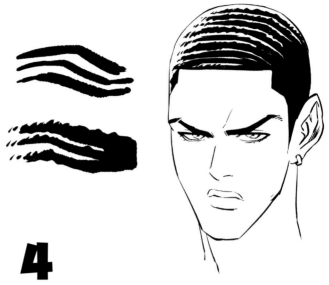

3

Draw slightly curved layered lines on the head. You decide how thick you want them to be.

4

Add more hair-like texture to the lines and fill in the parts of the head where light doesn't hit. Use this image as a reference.

5

Texturize the overall line for the shape of the head. Make it wavy in a subtle way to make the hairstyle look more organic.

PRO TIP: FADE IT OUT

ADDING A FADE TO THE SIDE OF A CHARACTER'S HEAD ADDS AN EXTRA DIMENSION TO THEIR PERSONALITY. ADD QUICK TRIM DASH LINES FORMING A GRADIENT FROM MORE HAIR TO LESS HAIR TO PULL IT OFF. THAT SAID, THE AFRO CAN TAKE ON ANY DETAILED LOOK AT THE TOP OF THE HEAD RATHER THAN WAVES. THE FOLLOWING SECTION EXPLORES THIS IN MORE DETAIL.

AFRO: HAIR PART

THE SIMPLEST WAY FOR YOUR CHARACTER DESIGN TO STAND OUT IS WITH A UNIQUE AND MANAGEABLE HAIRSTYLE CALLED THE "HAIR PART." TYPICALLY UTILIZING A PATTERN OF SOME SORT WITHIN THE SIDES OR BACK OF THE CHARACTER'S HEAD, THE POSSIBILITIES ARE ENDLESS. THIS STYLE IS MORE COMMON AMONG MEN AND WOMEN OF AFRICAN DESCENT, BUT ANY ETHNICITY CAN USE IT PROVIDED THAT THE HAIR IS SHORT AND CLOSE TO THE SKIN. IN THIS SECTION, WE SHOW HOW TO ILLUSTRATE YOUR DESIGN WITH THIS HAIRSTYLE.

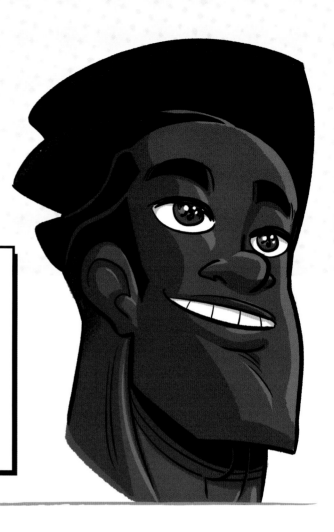

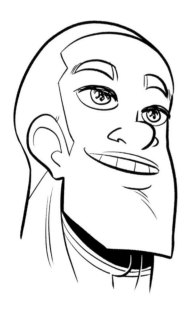

1

Draw the hairline. Make sure to curve it in the appropriate places to make the head seem round.

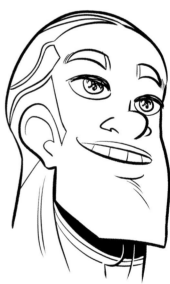

2

Now at the temple it's time to draw the part. Use the different hair part designs in this section for inspiration or make your unique fabulous creation. Just remember to curve the appropriate lines to make the head not seem flat and boring.

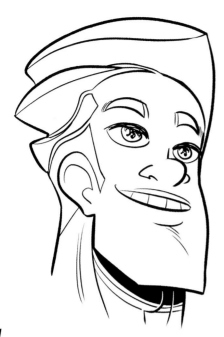

Draw the overall shape of the hair, incorporating the hair part or parts to bring more attention to them.

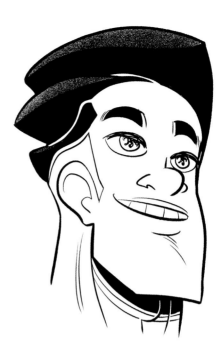

Fill in the hair, making the thick, dense parts of the hair solid black.

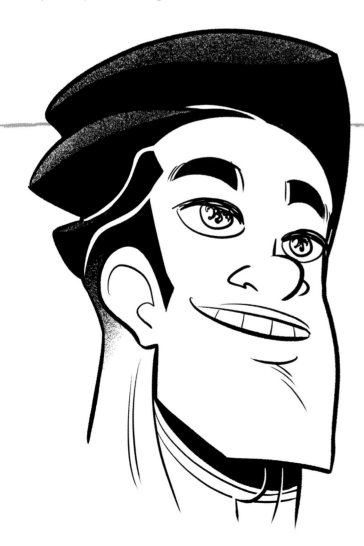

Then, fill in the "fade" portion of the hairstyle by drawing many tiny dots, putting them close together at the top so it appears darker and farther apart as you move toward the bottom to appear lighter (also known as stippling). It should gradually fade from black to white.

AFRO: HAIR PART VARIETY

AFROS COME IN ALL SHAPES AND SIZES, AND MOST BLACK MEN (AND SOME BLACK WOMEN) TEND TO WEAR THEIR HAIR SHORT OR CLOSELY CROPPED. MANY POC HAVE SIMILAR FEATURES AND DARK HAIR; THEREFORE, EXPRESSING INDIVIDUALITY TENDS TO BE REALIZED IN HAIR OR CLOTHES. ONE WAY FOR THOSE WITH SHORT HAIR TO EXPRESS THEMSELVES IS TO CUT SHAPES, NAMES, OR SYMBOLS INTO THE SIDES OF THEIR AFRO (A.K.A. A PART). THIS SECTION WALKS YOU THROUGH THE INCREDIBLE VARIETY OF SHORT, THICK HAIRSTYLES FOR CHARACTERS OF ANY ETHNICITY.

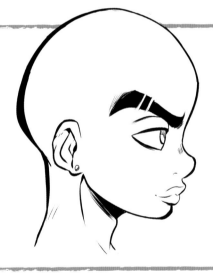

1

As usual, start with a bald head—the foundation for drawing all types of hairstyles.

2

Establish the shape of the hairline and part. The part itself can be as simple as a straight line going across the side of the head or going wild and crazy with various loops. In this example, we chose a pseudo-lightning bolt shape.

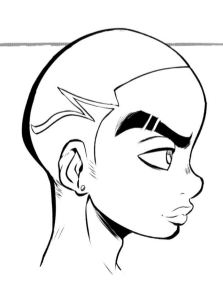

3

As the name implies, the hair will "fade" from dark to light, with the darkest part of the hair being at the top of the head. In this step, we will divide the head into three sections to simulate a fading effect. This gradient effect will make the part stand out.

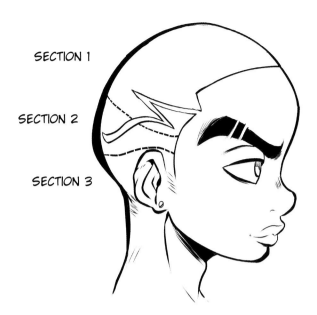

SECTION 1

SECTION 2

SECTION 3

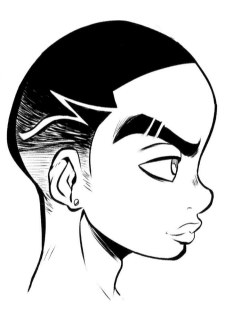

SOLID BLACK

TIGHT HATCHING

LOOSE HATCHING

4

In section 1, the hair will be solid black, representing the darkest part of the hairstyle. In sections 2 and 3, use varying amounts of hatching to illustrate the hair fading. Blend the sections with more or less hatching until you get the desired look.

5

And you're finished!

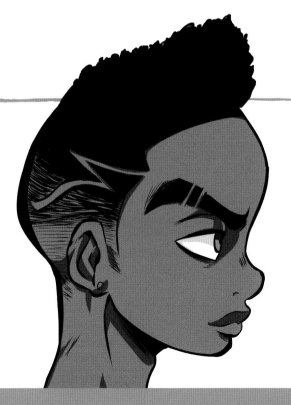

PART GALLERY

IT IS A MISCONCEPTION THAT AFROS ARE STATIC OR NOT AS INTERESTING AS THE STEREOTYPICAL MULTICOLORED, SPIKY MANGA HAIR. CURRENT HIT SERIES LIKE TOKYO REVENGERS BY KEN WAKUI SHOW A VARIETY OF LOOKS ON A VERY LARGE CAST OF JAPANESE CHARACTERS, RANGING FROM LONG, BLEACHED WAVY HAIR TO SKINHEAD LOOKS WITH TATTOOS TO PINK POMPADOURS. OUR ALL-AFRICAN MANGA, OBLIVION ROUGE BY PAP SOULEYE FALL, FEATURES BLACK TEENAGE CHARACTERS WITH HIGH-TOP FADES, DREADS, AND MULTICOLORED SHORT AFROS. THIS GALLERY BY RAYMOND BROWN DEMONSTRATES A NUMBER OF WAYS TO PRODUCE HAIRSTYLES FOR A DYNAMIC VARIETY AMONG CHARACTERS OF COLOR.

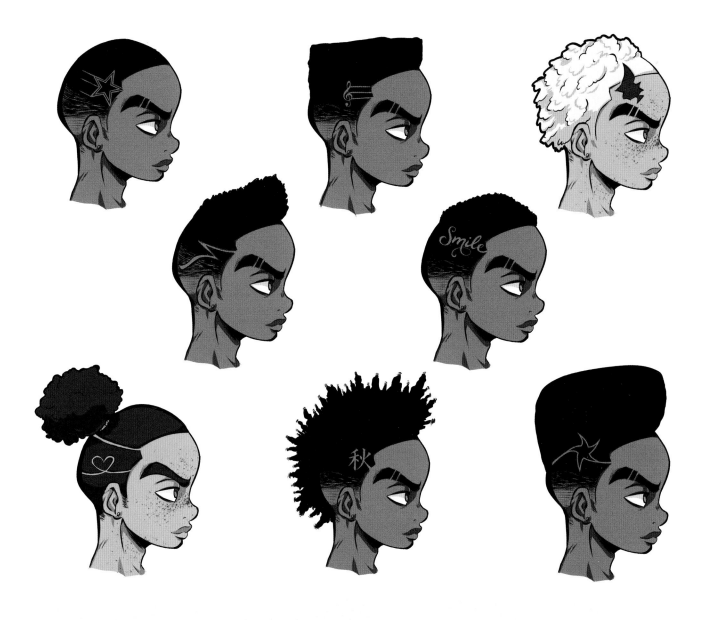

BALD & BALDING

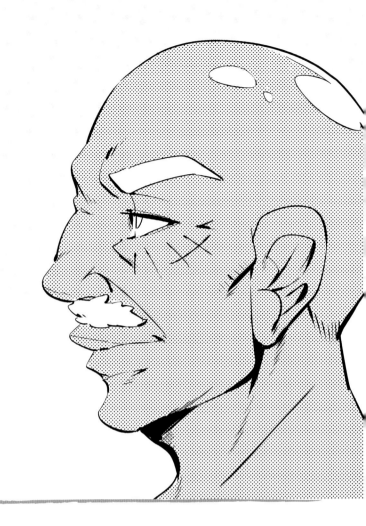

ONE LOOK THAT IS RARE IN THE MOST POPULAR JAPANESE MANGA, EVEN IN THE TRADITIONAL WHITE OR ASIAN CHARACTER DESIGN, IS BALDNESS - WHICH IS SHOCKING CONSIDERING THE POPULARITY OF ACTORS LIKE THE ROCK AND VIN DIESEL OR EVEN MEGAHIT SERIES LIKE ONE-PUNCH MAN BY ONE AND YUSUKE MURATA. IN THIS SECTION, WE EXPLORE HOW TO CRAFT CHARACTERS WHO ARE NATURALLY BALD OR CHOOSE TO BE.

FULL BALDNESS

A fully bald character is simple: start by drawing the shape of your character's head. TADA! That's it! You're all set! Easy, isn't it? If you'd like, you can choose to show "highlights" to add more detail. Ideally, show the highlights closer to the top or edge of the head, always keeping in mind where your light source is. Also, be sure to keep the shapes loose and imperfect to make them look more natural.

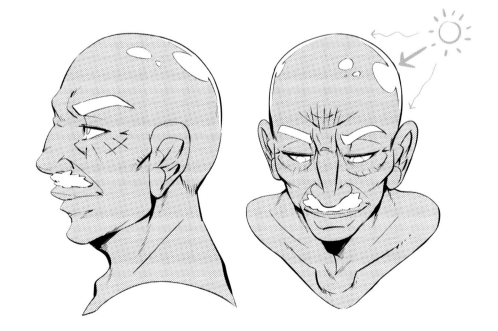

BALDING

1

Balding is different from full baldness; balding is when a person is becoming bald, meaning some amount of hair is still present. Balding patterns vary from person to person, and there are various stages if you show a character aging over time. Because of this, there are many ways to illustrate this hairstyle. Before you get started, map out important lines along with the character's head. This can include the overall shape, the hairline along the forehead, the center of the head, and so on.

2

A typical pattern is a type "M" balding pattern. Start at the centerline on either the left or right of the head, and then draw a sweeping curve toward the back. Return it toward the front of the head and stop at the hairline. Do the same for the other side of the head, being sure to make the lines symmetrical. Keep in mind the curved shape of the head as you're making these lines.

3

Complete the overall hair by connecting the lines back to the ears and the nape of the neck. Be sure not to draw the outer shape of the hair directly on the line for the head; hair has volume, so illustrating it too flat will make it look unnatural.

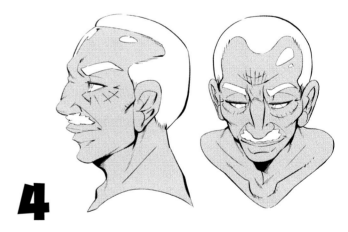

4

And you're done! You can add more details like feathering at the edges of the hair and highlights to emphasize the balding.

DON'T FORGET TO STUDY!

Balding patterns vary depending on age, sex, hair texture, and more. Be sure to study different forms of balding and then experiment to create more interesting character designs!

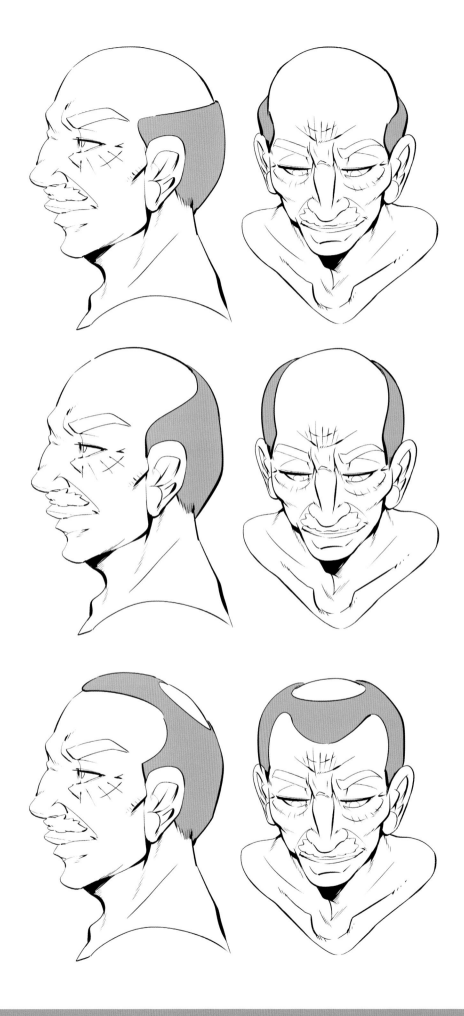

BRAIDS

A BRAID (OR PLAIT) CAN CONSIST OF TWO OR MORE STRANDS OF ANY HAIR TEXTURE OR FLEXIBLE MATERIAL WOVEN TOGETHER. AND BRAIDS CAN HAVE MANY STYLES, INCLUDING "FRENCH" AND "ROPE" CONFIGURATIONS. HERE ARE SOME TIPS AND TRICKS FOR CREATING YOUR VERY OWN BRAID STYLES FROM SCRATCH AND GETTING BETTER AT DRAWING THEM OVER TIME.

A

Add a simple zigzag and connect the pointed ends to the initial two lines with a slight upward tilt.

B

Add a subtle curve in between each point where the zigzags connect to the initial two lines.

Add lines to indicate hair strands pointed in the implied directions.

Add details and shading as desired.

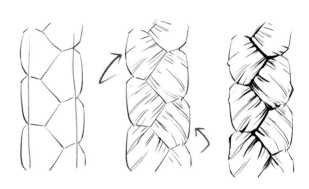

C

Create the shape (squares, triangles, etc.).

Add lines to indicate strands of hair, pointing to the center where the braids will connect.

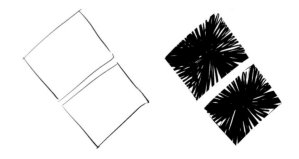

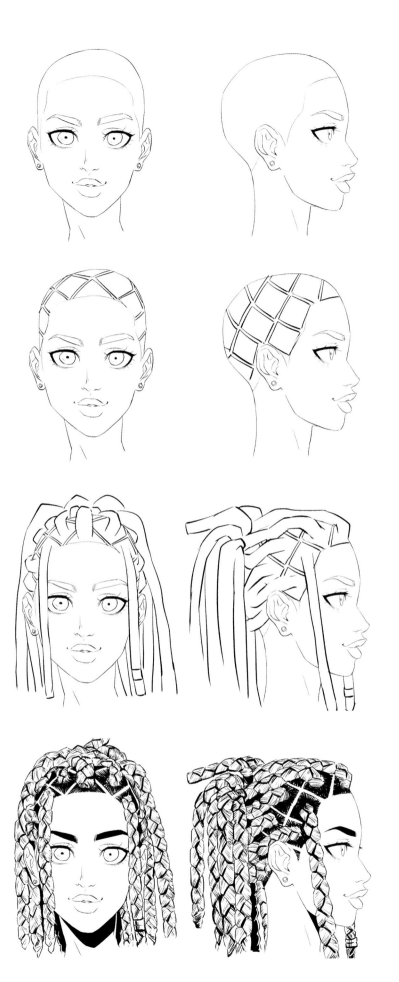

Now, place this style on a character.

1

Draw the hairline of the character.

2

Plot the scalp, where the roots will be.

3

Decide how thick or thin the braids will be and place them on your character in your desired style.

Render the knot style and root details on your design.

4

Add edges as desired. Here, we've gone for a curly approach.

And you're done!

DETAILED BRAIDS

1 Start with a cartoon-style head similar to the one we used for the stylized Afro and Afro hair part tutorials.

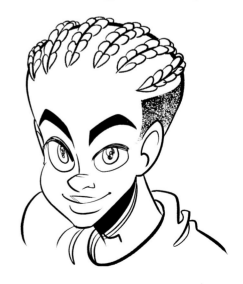

2 Draw several lines on top of the head. Curve along with the head shape, and don't be afraid to create different designs.

3 Stemming from each of the lines you drew in step 2, draw a heart-like shape to represent each braid.

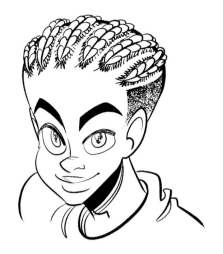

4

Now add the hairs connecting the braid to the head.

To do this, draw curved lines from the bottom of each braid onto the scalp.

5

Add detail by drawing curved lines within each braid to make it look rounder and more shiny.

This step may take a while, depending on the style of braids you choose to use.

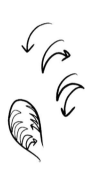
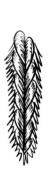
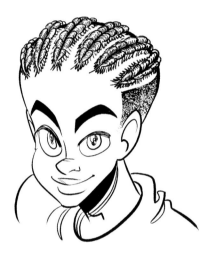

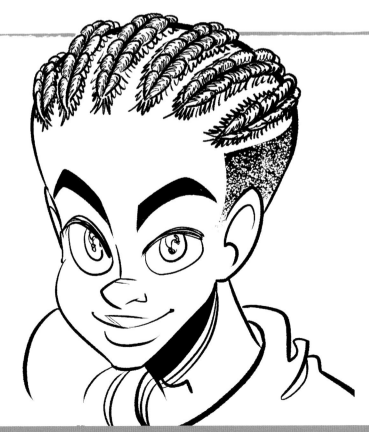

6

Congrats!

This final version featuring intricate braids demonstrates that this hairstyle can work even for a cartoon-style character.

DREADLOCKS

DREADLOCKS, OR "LOCS," ARE A MULTICULTURAL HAIRSTYLE ENJOYED BY MANY DIFFERENT ETHNICITIES. PEOPLE FORM THEM BY TAKING HAIR STRANDS AND WEAVING THEM TOGETHER. THE DIFFERENCE IS THAT BRAIDS ARE FRESHLY MAINTAINED, WHEREAS LOCS ALSO REQUIRE MAINTENANCE OVER TIME BUT DO NOT HAVE TO BE BRUSHED OR CONDITIONED. THIS SECTION WILL EXPLORE A VARIETY OF STYLES FOR CRAFTING DREADLOCKS.

1

Draw the hairline.

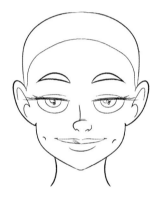
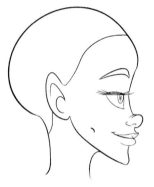
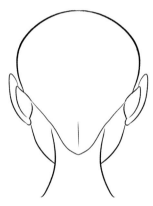

2

Sketch out the shape of the hair.

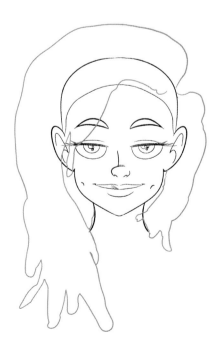
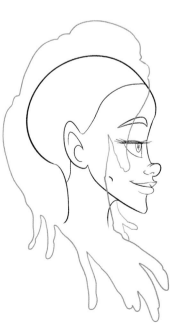
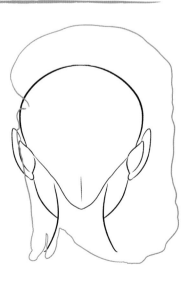

3

Fill the hair shape you just drew with noodle-like strands of various sizes. Each strand should look somewhat uneven and bumpy. Feel free to overlap or even tangle the strands. Take inspiration from photos of real-life loc designs to get an idea of how thin or thick you want to draw yours.

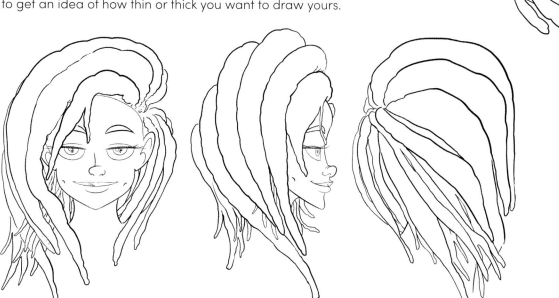

4

After drawing all of the hair strands, it's time to add detail. There are several different ways to add detail, but here are a few texture drawing techniques.

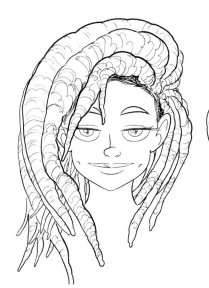

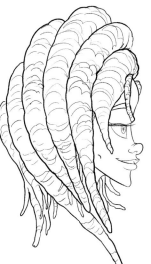

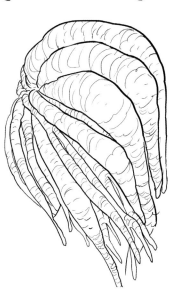

These are obviously very stylized, but you can seek out other references and try different techniques to replicate the look you're personally going for.

HERE ARE A FEW MORE EXAMPLES:

1 **2**

3 **4**

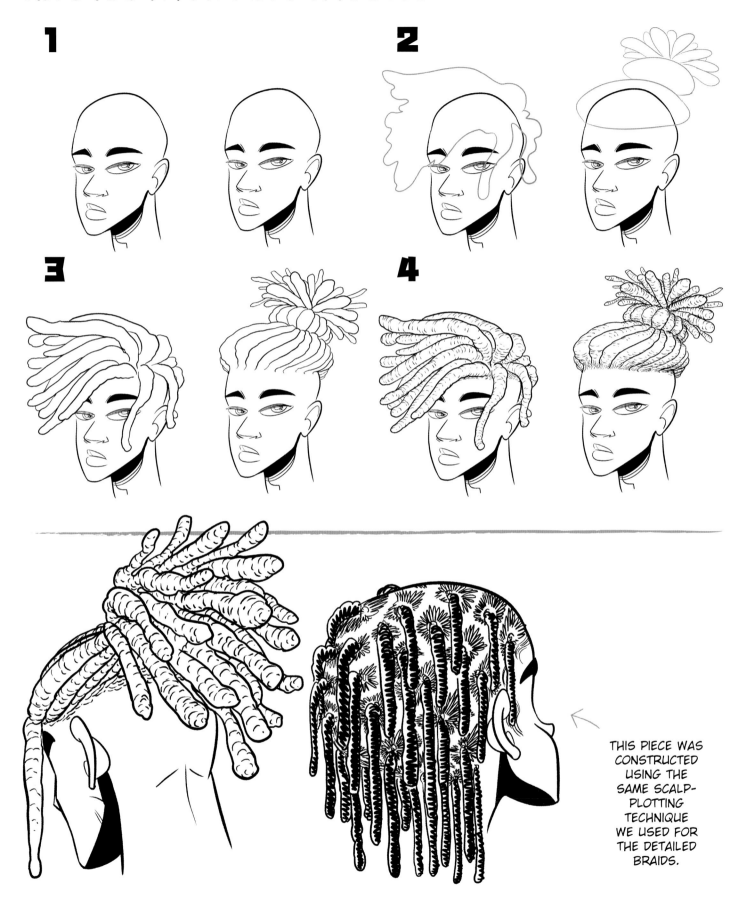

THIS PIECE WAS CONSTRUCTED USING THE SAME SCALP-PLOTTING TECHNIQUE WE USED FOR THE DETAILED BRAIDS.

JEYODIN: TIPS FOR BLACK HAIR

THERE ARE COUNTLESS TRADITIONALLY BLACK HAIRSTYLES BECAUSE OF OUR RICH ROOTS AND CULTURE, FROM HIP-HOP STYLES TO AFRICAN STYLES - INCLUDING LOCS, TWISTS, BUZZ CUTS, AFROS, FADES, CORNROWS, AND MORE. GET CREATIVE WITH IT! ALSO WORTH NOTING ARE THE UNIQUE CHARACTERISTICS OF BLACK HAIR, SUCH AS TEXTURE, AND IT WOULD BE NICE TO PORTRAY THESE ASPECTS IN YOUR WORK.

AS ALWAYS, THERE ARE A FEW THINGS TO KEEP IN MIND THAT ARE COMMON WITH HAIR ON BLACK OR DARK-SKINNED PEOPLE MORE THAN NOT. THERE IS ALSO A SWEET SPOT HERE: DON'T BE DISRESPECTFUL, DON'T OVERDO IT, BUT DON'T BE APATHETIC EITHER. IT IS BEST TO RESEARCH THE VARIOUS BLACK HAIRSTYLES OUT THERE AND UNDERSTAND THE PROCESS FOR CONSTRUCTING THEM.

THERE ARE TIMES WHEN A BLACK CHARACTER MIGHT, FOR WHATEVER REASON, HAVE STRAIGHT AND/OR UNUSUALLY COLORED HAIR, WHICH IS FINE. HOWEVER, IT WOULD BE WEIRD IF ALL OR EVEN MOST OF YOUR BLACK CHARACTERS' HAIR IS DEPICTED AS STRAIGHT WITH NO JUSTIFICATION WHEN THERE ARE SO MANY RICH BLACK HAIRSTYLES TO CHOOSE FROM.

IN FACT, THERE ARE SO MANY DIFFERENT BLACK HAIRSTYLES THAT TRYING TO DRAW THEM ALL HERE WOULD BE IMPOSSIBLE. BUT HERE ARE A FEW TIPS ON DRAWING CARTOONY VERSIONS OF A FEW OF MY FAVORITES.

Whenever I draw locs, I try to make them as simple as possible. After removing the shape of the hair, I separate it into long noodle-like strands of hair, and then I draw a curved line from one end to the other repeatedly. This tactic gives the illusion of "braided" locs. It's quick and fun, and I'm thrilled that I've been able to use it to draw different hairstyles.

Another cool hairstyle to draw is the curly Afro. It's like drawing uniform chaos, and quite frankly, it looks a lot like what an anime character would do to their hair if they could. My recommendation is to draw the shape of the hair you have in mind and then make it look more defined. After that step, add small, uniform curls or lines coming up from the hair to keep it looking somewhat realistic.

FACIAL HAIR

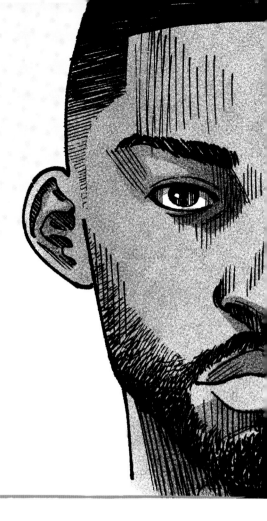

REMEMBER WHEN WE MENTIONED THAT BALDNESS IS RARELY SEEN IN JAPANESE MANGA? ANOTHER RARELY SEEN STYLE IS FACIAL HAIR. IN POPULAR MEDIA, GOATEES HAVE OFTEN BEEN USED TO SIGNAL AN EVIL CHARACTER. TODAY, TENS OF MILLIONS OF MEN WORLDWIDE SPORT MUSTACHES, AND MANY NOW PROUDLY WEAR LARGE FULL BEARDS, LIKE NBA STAR JAMES HARDEN.

THIS SECTION DEMONSTRATES HOW TO CREATE DIFFERENT STYLES OF FACIAL HAIR USING THE SEINEN ART AESTHETIC.

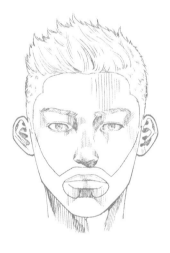
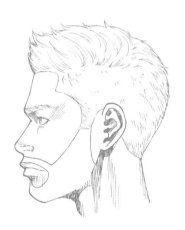

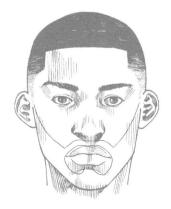
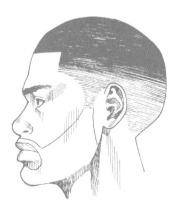

As with the hair on top of the head, start by creating a hairline for the facial hair.

The lines should come down the bottoms of the cheekbones and taper toward the corners of the mouth.

STUBBLE

Press gently with a pen or pencil while making short, quick strokes to create stubble.

By following the hairline you created, the result will be a five o'clock shadow. The lines do not all need to be of the exact same weight since stubble doesn't grow perfectly even.

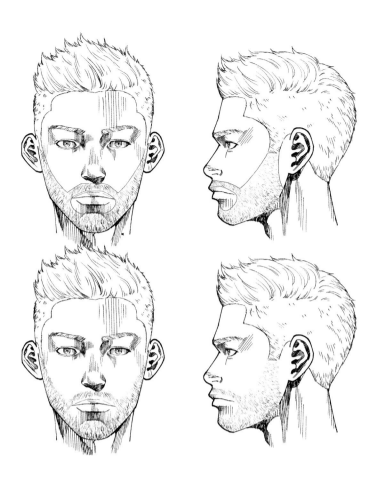

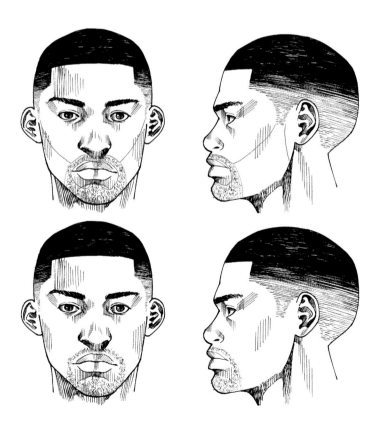

GOATEE

In this example, the green lines show "cuts" in the five o'clock shadow shape.

The result when the stubble is filled in is a goatee.

By making short strokes in different directions, you can create stubble that looks like it is beginning to form a curl pattern

FULL BEARDS

For thicker facial hair, follow the same red guidelines from the previous page. A longer beard will fall past the jawline, and a more pronounced mustache may fall over the upper lip.

When rendering hair in significantly lighter colors, think of groupings of hair instead of individual strands. Drawing each strand will make it appear too busy and darker than intended. Instead, add detail only in areas where less light would reach, like under the bottom lip and the beard's edges.

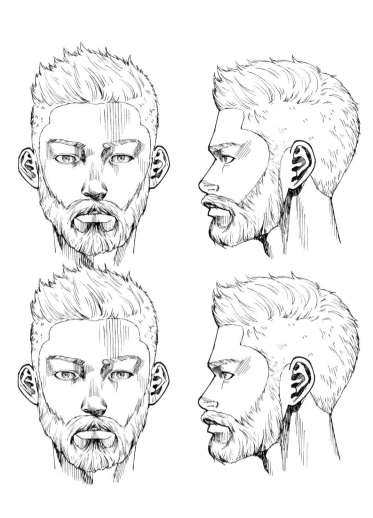

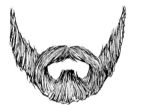

RENDERED IN GROUPINGS

DETAILING EACH STRAND IS TOO MUCH

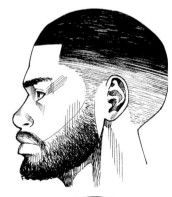

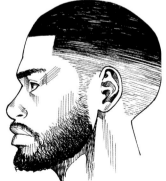

GRADATED BEARDS

In this sample, follow the same red guidelines to define the beard area. By making gradually more and thicker strokes, you can create a fade into a thicker beard. This beard is very dark, to the point where it's difficult to see individual strands at their widest. By adding strands peeking out from the edges of the beard, you can show there is a curl pattern.

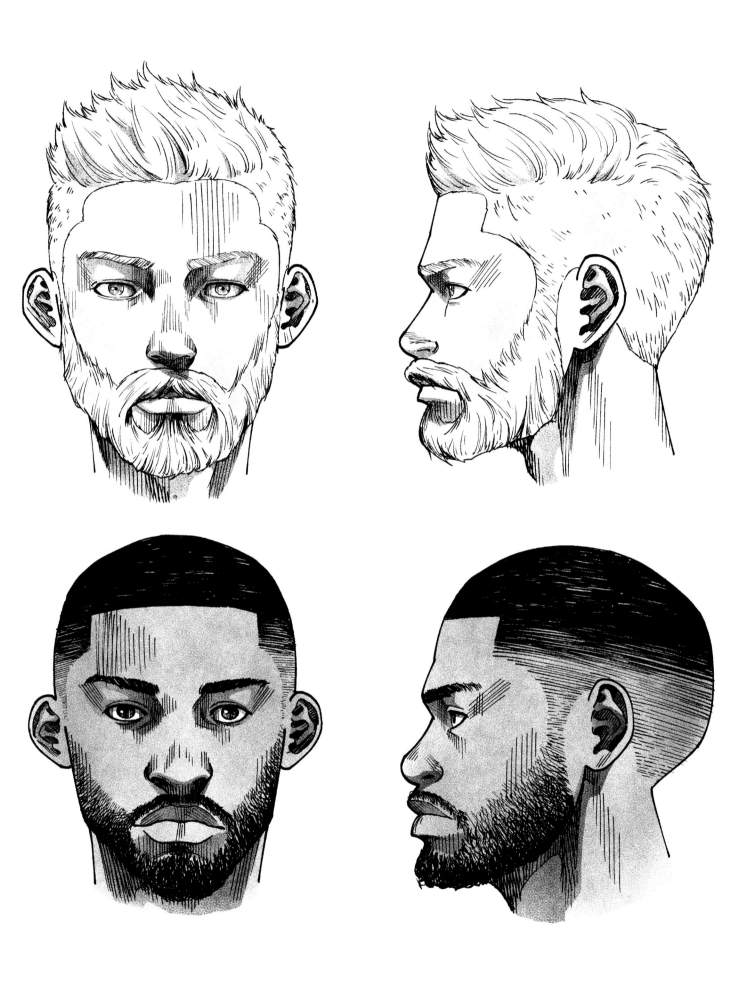

STRAIGHT HAIR: BANGS

BILLIONS OF PEOPLE OF VARIOUS ETHNICITIES HAVE STRAIGHT HAIR, AND IT SERVES AS THE BASIS FOR MOST JAPANESE MANGA CHARACTERS. HAIR CAN BE COARSE OR THICK; IT CAN BE MULTICOLORED AND PRESENTED IN VARIOUS STYLES, INCLUDING BOBS, BANGS, OR LONG. THIS SECTION EXPLORES HOW TO ILLUSTRATE DIFFERENT LOOKS FOR YOUR CHARACTER.

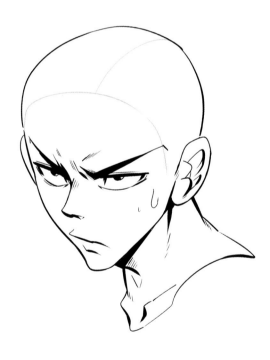

1

Start with the shape of your character's head.

Map out the part line for the overall hair and where the brow line is going to be.

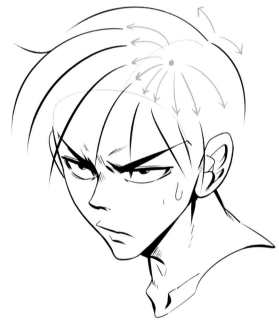

2

Imagine a focal point somewhere on the top of the head, near or on the part line.

Draw curved lines away from this point. You can draw these lines longer or shorter, depending on the desired length of your character's hair.

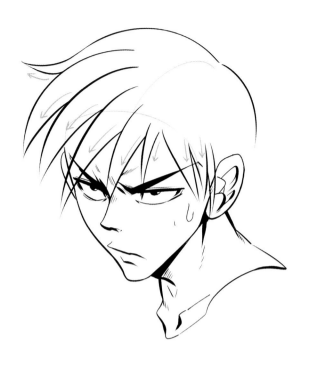

3

Starting somewhere along each of the lines you just made, draw another line away from it and connect it to the end of the line you previously illustrated. As you do, you'll see zigzagging, pointed shapes appear; these are your character's bangs.

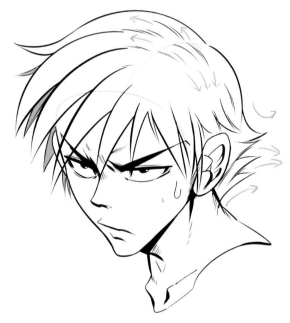

4

Now add details. For this character, we added a cowlick at the back of the head, added more strands of hair on the other side of his face, and further refined the direction of the hair on top of his head.

5

And you're done!

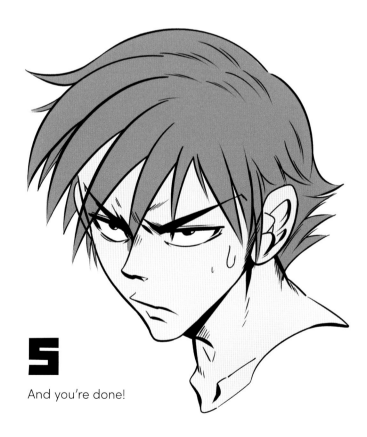

STRAIGHT HAIR: LONG

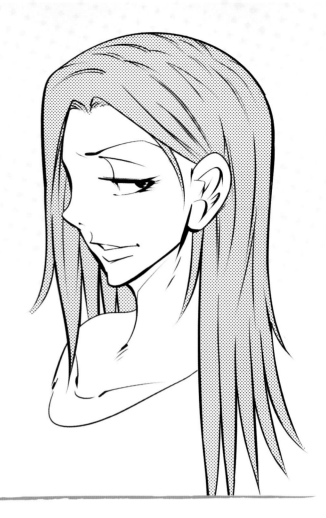

TRADITIONAL JAPANESE MANGA IS NOTABLE FOR THE DYNAMIC HAIRSTYLES OF THE MOST POPULAR CHARACTERS. THE FAMILIAR, LONG STRAIGHT HAIR ON MAJOR CHARACTERS IS RARER BUT NOT ABSENT, AS HEROES LIKE INO YAMANAKA (NARUTO), AND BAJI KEISUKE (TOKYO REVENGERS) PROVE. THIS SECTION SHOWCASES SOME IDEAS ON HOW TO USE THIS HAIRSTYLE WHEN CRAFTING YOUR DIVERSE CHARACTER DESIGN.

1

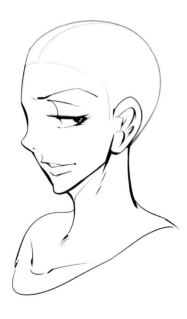

Start with the shape of your character's head.

Put down a guideline for where the part line of the hair will be.

2

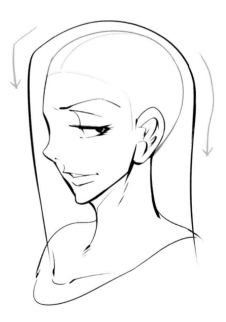

Outline the head for the overall shape of the hair. On top of the head, the hair should sit a short distance above the shape of the skull, then drop straight down when it reaches the forehead and the back of the head.

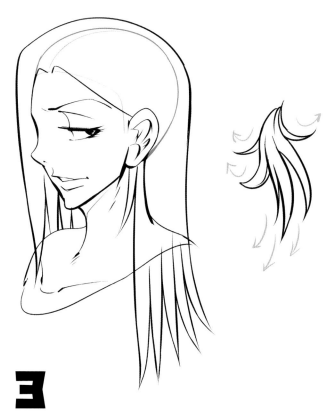

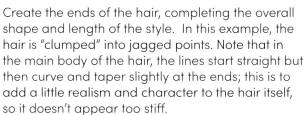

3

Create the ends of the hair, completing the overall shape and length of the style. In this example, the hair is "clumped" into jagged points. Note that in the main body of the hair, the lines start straight but then curve and taper slightly at the ends; this is to add a little realism and character to the hair itself, so it doesn't appear too stiff.

4

Lastly, add details such as thin lines to show direction throughout the overall hair, defining the hair as it sits on the forehead, and adding stray strands on the edges of the hairstyle.

5

These are two more ways that you can illustrate straight hair. As with any hairstyle, straight hair comes in many shapes and sizes: it can be long or short, have different cuts on the ends, and even be limited to certain parts of the head.

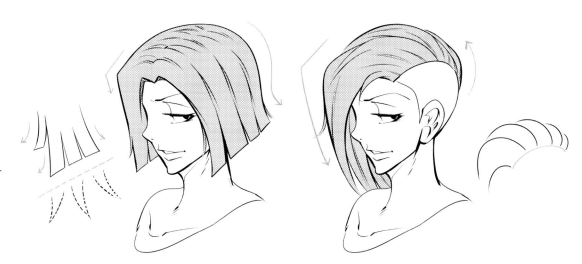

STRAIGHT HAIR: BUNS

A BUN IS A CIRCULAR PATTERN RESULTING FROM THE INTERLOCKING OF HAIR STRANDS OR BRAIDS AND WILL TYPICALLY SIT ON THE TOP OR BACK OF THE HEAD. THERE ARE MANY METHODS TO TYING A BUN, SO WE'LL GO THROUGH THE BASIC PROCESS FOR THIS EXAMPLE.

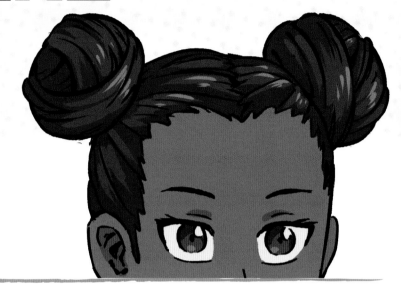

SINGLE BUN

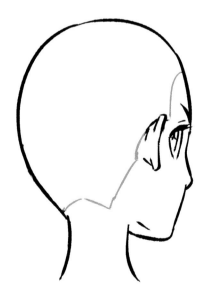

1

Determine where on the head you want to position the base of the bun.

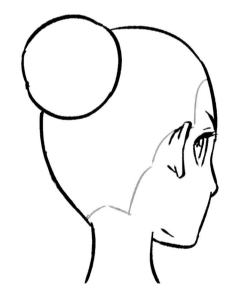

2

Simplify creating a hair bun by drawing a ball on the portion of the head that you have selected for the bun.

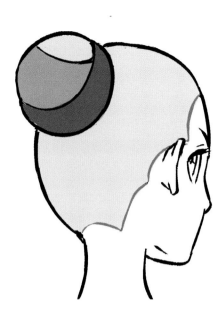

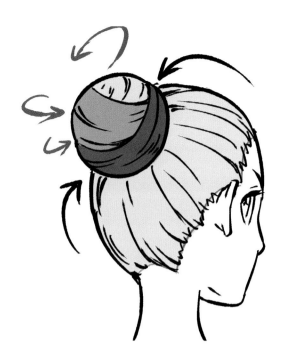

 3

Since the bun forms due to hair wrapping around itself, you can separate it (as indicated by the shading).

4

When adding more details in the hair strokes, make them lead toward the bun.

The hair strokes in the bun can be tricky to grasp on appearance, especially since not all buns are tied in the same way, so it helps to emphasize the sense of direction in the hair strokes – much like drawing a natural swirl or rotation.

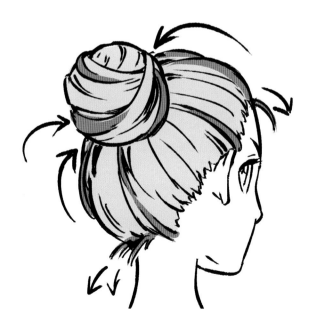

 5

You can make the bun appear less tight and more casual by adding smaller sets of hair strands puffing out from the base of the head and bun.

TAKE IT TO THE NEXT LEVEL

ALLOW SOME HAIR STRANDS NOT TO BE PART OF THE BUN FOR A MORE FREE-FLOWING STYLE.

MULTIPLE BUNS

In drawing two or more buns, it's essential to distribute the different sections of the hair accordingly.

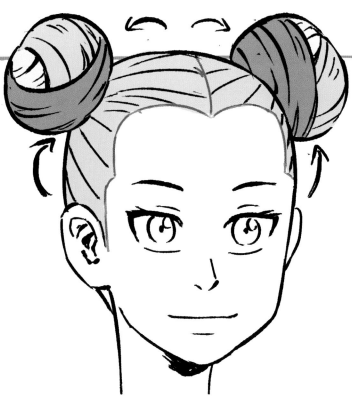

1

In this example, with two buns of equal size, the dividing line should between the buns.

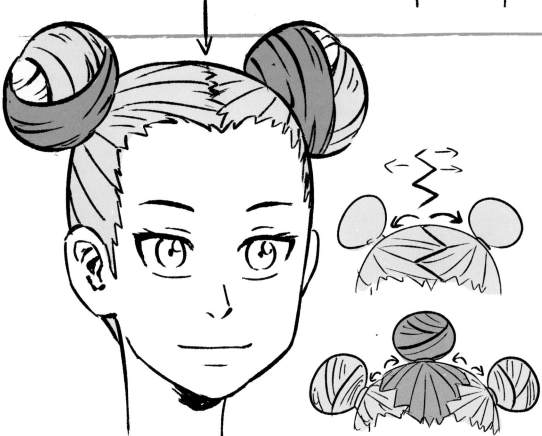

2

When adding the extra details on the hair strokes, the dividing line betwbecomes another hairline.

You can play around with the extra hairline with a zigzag pattern and even add more buns as long as you can distribute the hair appropriately.

FREEFORM BUNS

As there are many ways to tie a bun, you are not limited to the standard round bun.

A bun is not limited to layered swirls; as long as you apply a sense of direction in the hair, the only limit is your imagination.

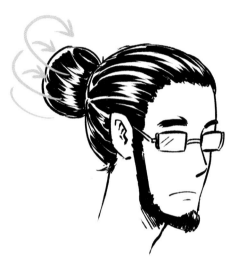

YOU CAN ADD A SECTION WHERE THE HAIR LOOPS AROUND THE BASE OF THE BUN.

Buns sometimes maintain their shape with hidden hairpins. You can add visible accessories like hairpins or hair ties to add a neat touch—even a pencil as a hair stick can work.

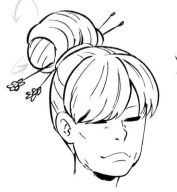

Experiment with different shapes, like cones, long buns, horns, and whatever else you can imagine.

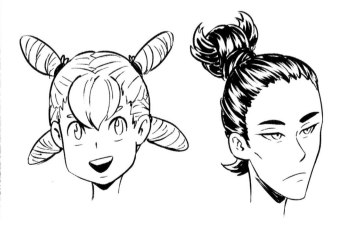

STRAIGHT: TWO BLOCK

THE TWO-BLOCK HAIRSTYLE FEATURES TWO DISTINCTLY DIFFERENT HAIR LENGTHS (HENCE THE NAME) - TYPICALLY SHORTER IN THE BACK AND ON THE SIDES AND LONGER ON TOP. SIMILAR TO AN UNDERCUT OR BOWL CUT, THIS HAIRSTYLE IS TRENDY IN EAST ASIA.

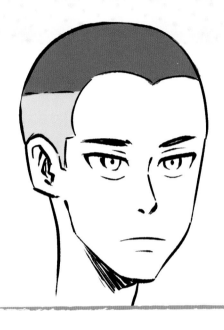

1

Divide the hair into two parts: the lower half and the upper half.

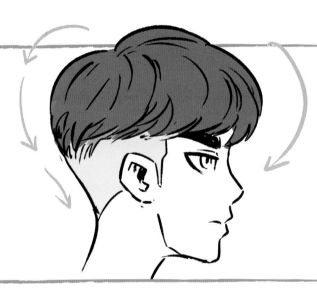

2

When drawing the top half of the hair, make it much longer and drape it over the lower half of the hair.

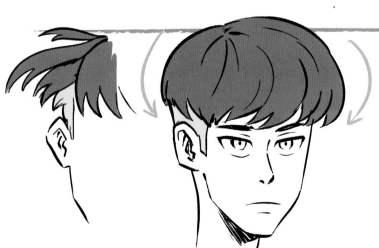

3

Even though the two sections are different lengths, maintain a smooth, gradual slope as the hair goes down from the top to the lower half.

HELPFUL TIPS:

Remember: the top part of the hair will always have more volume than the back and sides.

The more obvious two-block style can resemble the shape of a mushroom.

The style can be more subtle when the hair isn't flowing downward.

PART THREE:

THIS SECTION SHOWCASES BASIC HUMAN
ANATOMY TO HELP YOU CONSTRUCT
PROPORTIONATE BODY TYPES. WE WILL ALSO
FOCUS ON DIVERSE BODY PROPORTIONS TO
PROVIDE A MORE INCLUSIVE AESTHETIC FOR
DYNAMIC CHARACTER DESIGNS.

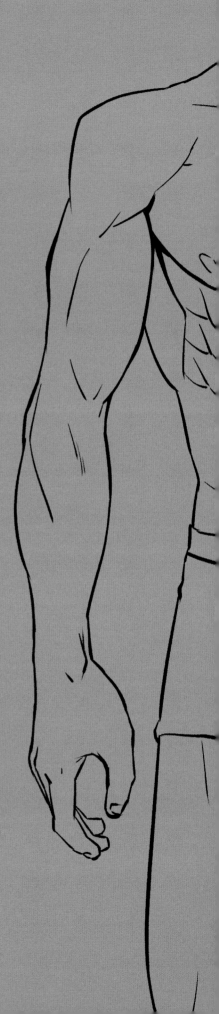

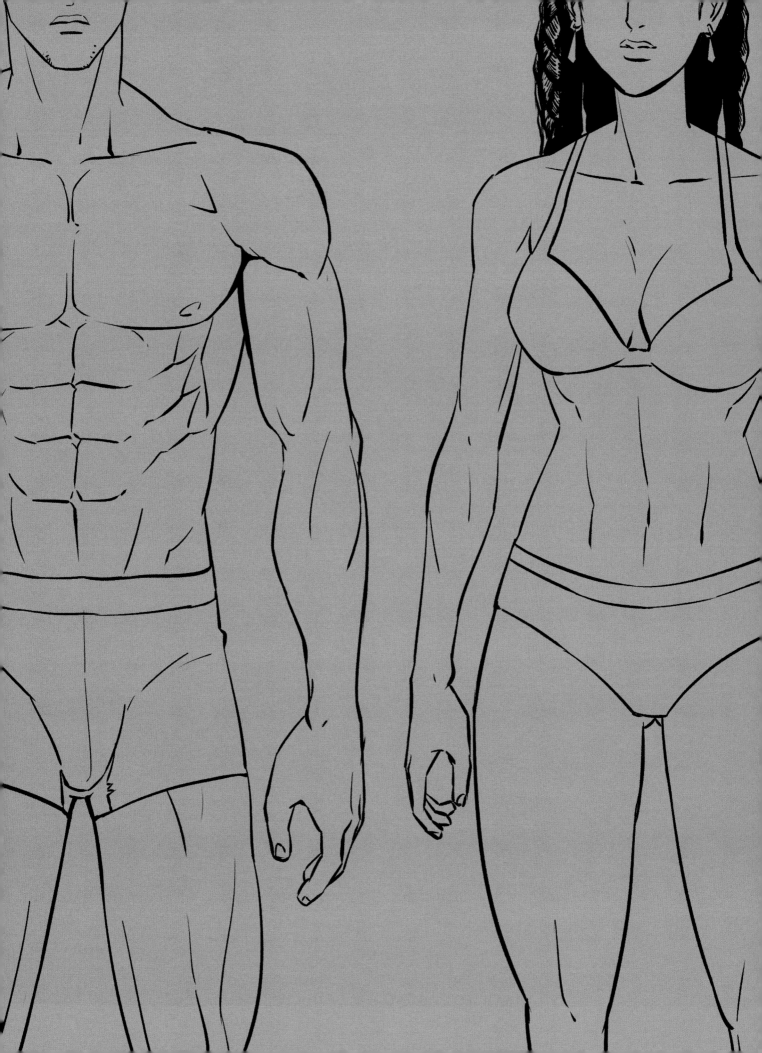

BODY PROPORTIONS

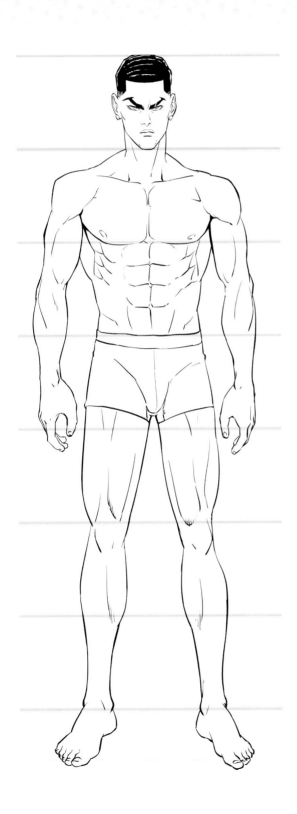

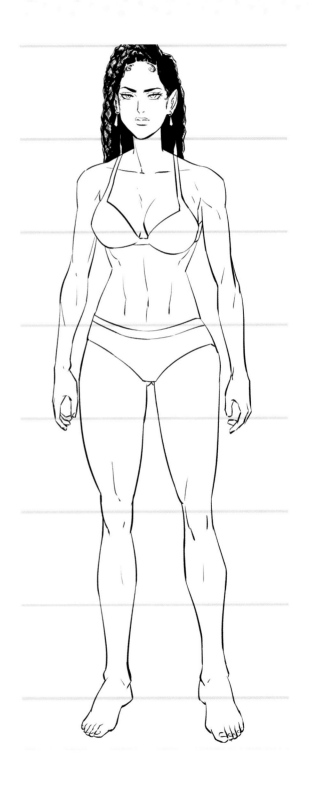

To truly be able to draw the human body from various angles and in various positions, you need to understand the standard proportions of body parts relative to other body parts. One of the most important things to take note of is the ratio of head size to body height. An adult human's height is usually six to eight times the height of their head; a body seven times the height of the head and above is usually used for taller figures, while the lower numbers are for the shorter characters. Ultimately, it varies and mostly depends on your discretion.

There are exceptions to this rule, with the diverse kinds of people out there in the world—and some artists can break this rule for a host of reasons, especially due to their art style—but it's good to know the rules before you break them.

This ratio also changes depending on the age of a character. The shapes of some body parts will also vary with the age group; for example, the face tends to be rounder in younger figures. Be aware of how you can adjust all these rules with different art styles as well. Below is a visual guide to the body proportions for different age groups.

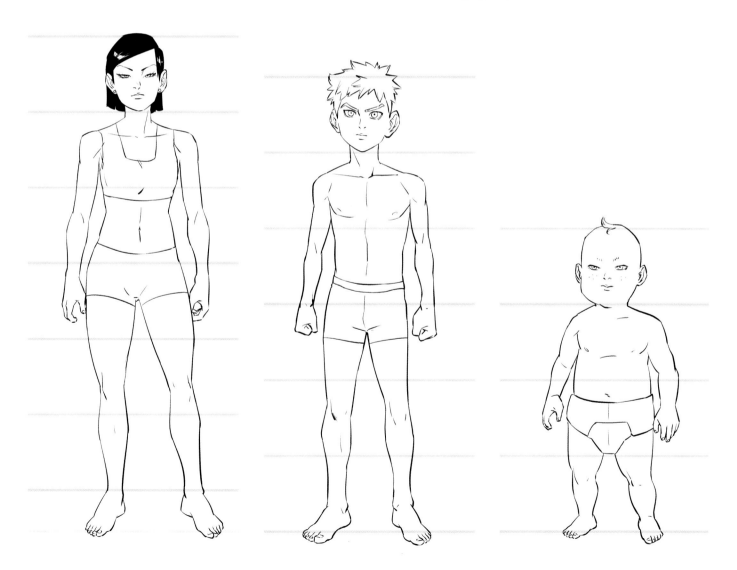

CONSTRUCTING A BODY

To fully understand the human body, we highly recommend studying real-life images of diverse kinds of people in the world. This will inform you on what to watch out for when drawing: keep track of where muscles connect, how they change when the body moves, and certain curve lines for the body that will make your drawing come together well. When constructing the body, start with a loose sketch before attempting your more defined lines. We will begin with a typical body frame and then use a few alterations to create new body types of your choosing.

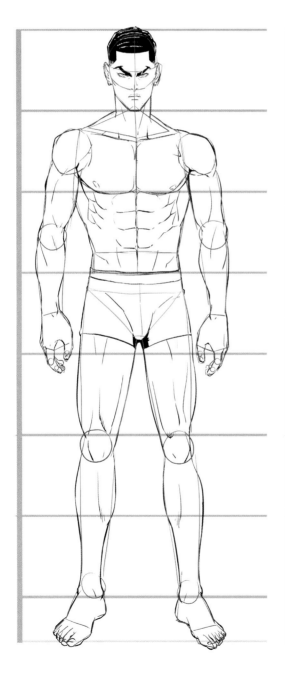

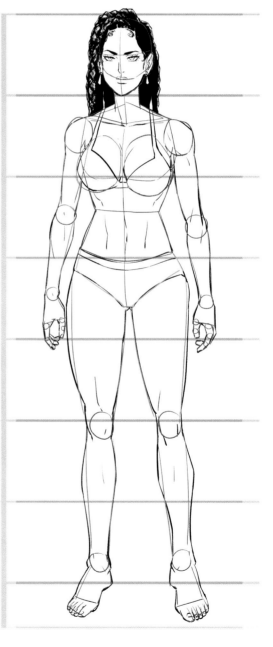

Begin by sketching the head (see page 13).

Use simple shapes to sketch out the general body shape in proportion to the head.

Note that male and female bodies tend to have slightly different proportions. See page 88 for more on different body types.

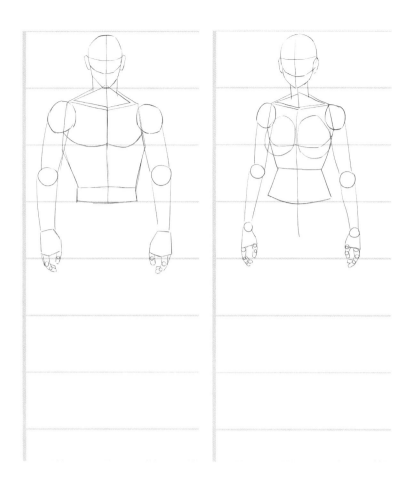

Draw out the arms and hands, making sure the hands fall below the waist when the arms are hanging straight down. You can draw the fists in the proper place first, then sketch circles for the elbows, and then connect the dots.

Add the legs, taking a similar approach as with the arms and hands; once you know where the feet are supposed to be (using the guideline of an adult being six to eight heads tall), place the knees somewhere in the middle and then connect the lines for the legs.

After sketching out the feet as illustrated, use quick, simple lines to show the separation for the toes.

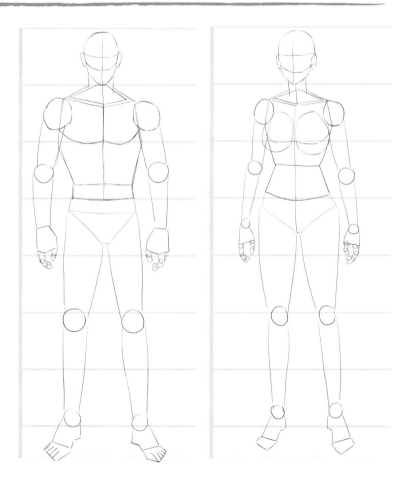

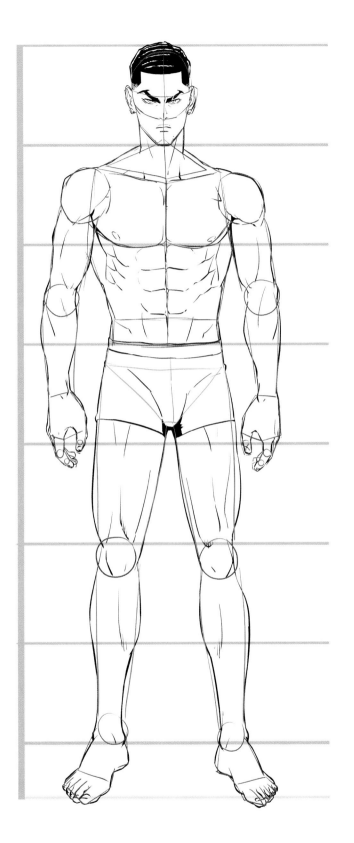

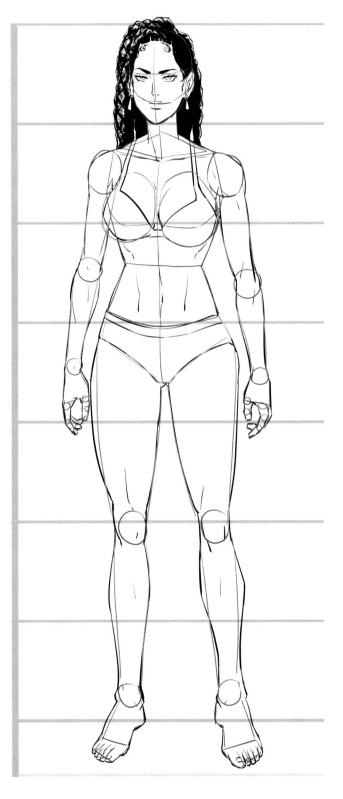

Optional: Finish the overall sketch of the body before adding your defined lines.

Study and learn how the lines for the muscles are displayed and what lines on the body curve in and out for the different genders.

DIVERSE BODY TYPES

HEROISM OFTEN FEATURES ATHLETIC CHARACTERS FOR MEN AND VERY PETITE CHARACTERS FOR WOMEN, BUT WE KNOW THAT BRAVERY AND HONOR HAVE NO "IDEAL" SHAPE IN THE REAL WORLD. HERE ARE THREE HEROINES, EACH WITH A UNIQUE BODY TYPE THAT HELPS TO SUPPORT HER PERSONA. NONE IS A SIDEKICK OR STEREOTYPE BUT IS AS TRUE TO LIFE AS THE ARTIST WHO MADE HER.

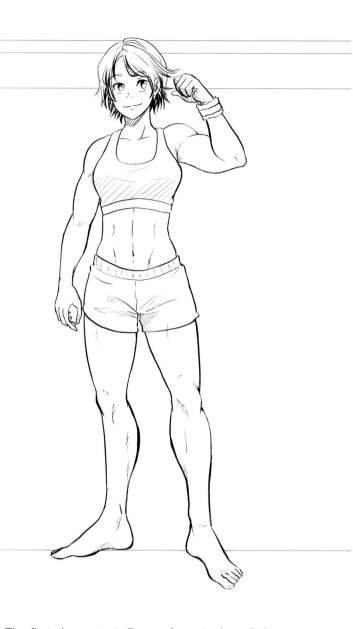

The first character is **Emese** from Andrea Otilia Doney's series **KILLSHOT**. A 20-year-old Division I volleyball player, she is tall and sporty. Volleyball primarily requires flexibility and strength in the legs, so her legs and core are defined, but not buff like a bodybuilder's. Simple hatching-style shading is used to indicate the definition of the muscles. You can study photos of real female athletes to achieve a realistic body image and avoid any anime clichés, such as out-of-proportion, physically impossible hourglass shapes.

It's important for artists not to feel that they need to draw female characters only in a "sexy" way just because that's what's typical in both Japanese manga and Western comics.

Every shape and size is beautiful on its own; you don't need to blow things out of proportion for the sake of fanservice.

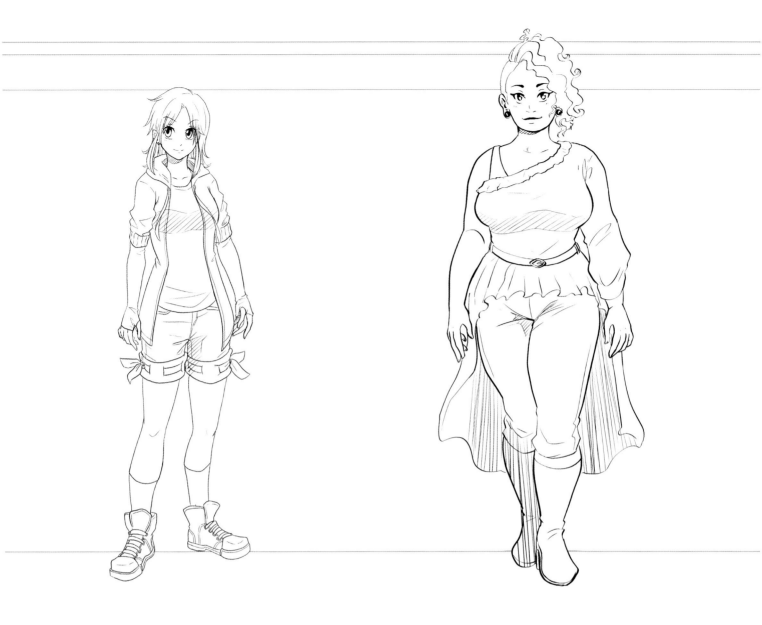

The second character is **Ayumi** from Saturday AM's series **SAIGAMI**. She's 16 years old and can summon and control elemental flames. She is a petite girl with a fragile build, and while she tries her best, she's nowhere near the athletic level where she has any muscles to show off.

Her design aims for a realistic body for a young girl: thinner limbs, slim shoulders, and subtly defined waist, hips, and breasts. When drawing girls and young women, especially underage characters, make sure not to sexualize them. There's grace and dignity in designing your characters as relatable figures.

Staying with SAIGAMI, let's look at a third elemental warrior character design. She's in her early 20s, tall, powerful, and comfortable in her body.

Here, the character design uses more rounded and oval shapes to accentuate the character's curves. She has a confident stance and a fuller build, with thicker thighs and more prominent hips and breasts.

Remember that bony areas, such as joints, lack muscles and the space to build body fat when drawing buff, muscular, fluffier, or plus-sized characters. Also, take into consideration that gravity always affects the body! While a toned, athletic build will look firm and more solid, a heavier but less muscular figure can have parts that look softer or lumpier, or that even sag a bit, depending on the character you're drawing.

SKINNY

Skinnier figures will tend to have smaller and less defined muscles and less fat, with a figure closer to their skeletal structure. Make sure to add lines on the body to show more of the bones underneath, like the ribcage, than to show muscle

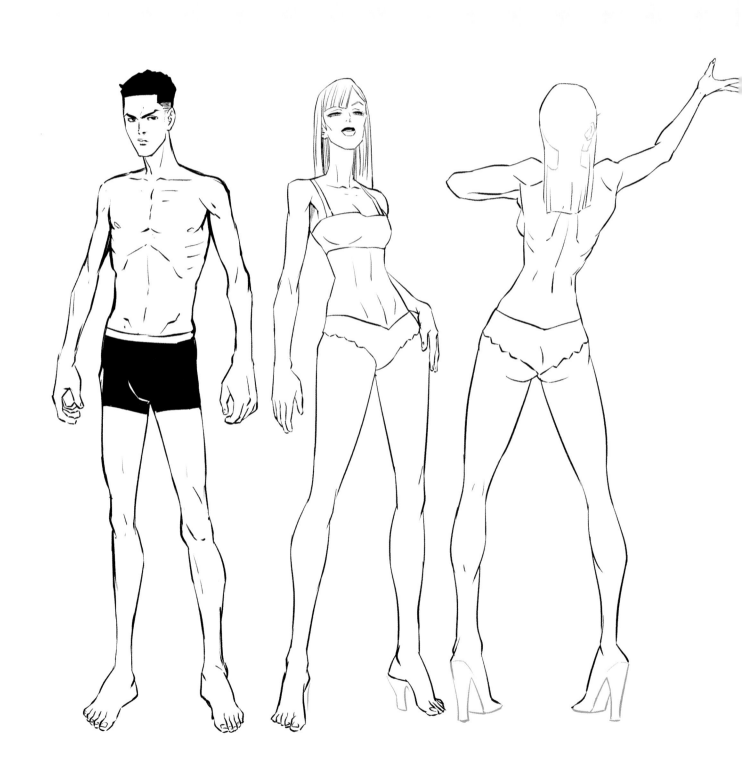

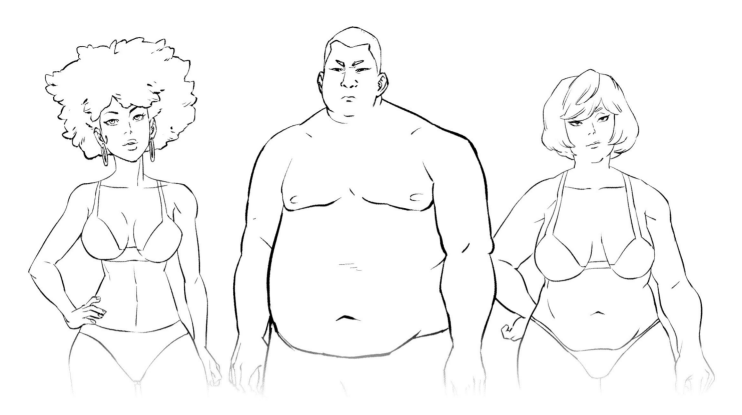

CURVY

For plus-size figures, we advise you have a decent understanding of where fat is generally stored on the body.

These areas are commonly around the belly, chest, upper arms, thighs, and cheeks, with genetics playing a role on where it is stored in each person.

Starting with the standard body form, add more definition to those areas first. Being able to mix and match where you add definition for a plus-sized character is a building block to learn. Eventually you should be comfortable drawing the exact body type you want.

The areas shown in color indicate where fat would typically be first added or removed when using this technique.

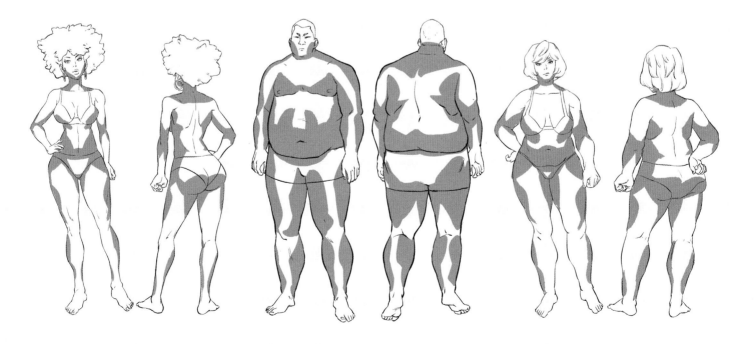

MUSCULAR

In general, use more lines to show the muscles on a character's body the more shredded they are. You may also increase the muscle sizes to show how strong the character is in a traditional sense. Having a strong grasp on muscle anatomy will guide you in where to add more volume to show more physical strength.

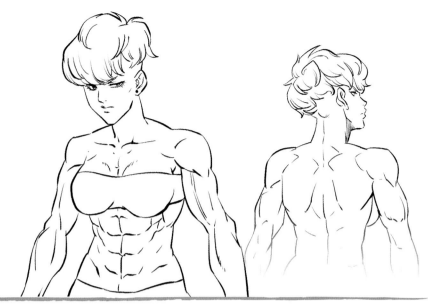

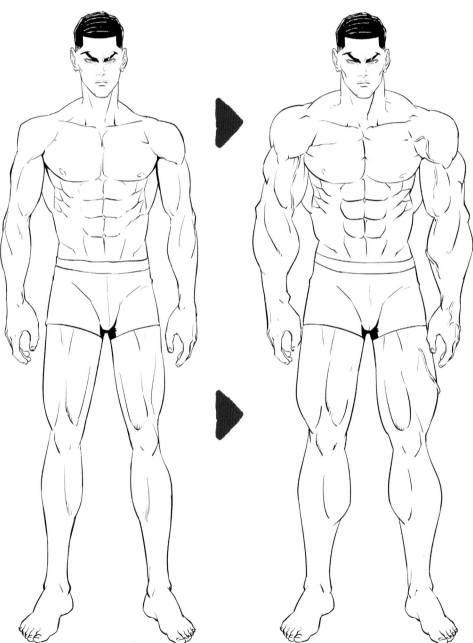

Here are two muscular bodies, with one bulkier than the other.

- The shoulder areas protrude more on bulkier figures than on less muscular ones.
- More veins show on shredded figures.
- A very muscular character will generally have a much thicker neck.
- All muscles can expand and be drawn large depending on how physically strong the character is.

AGE

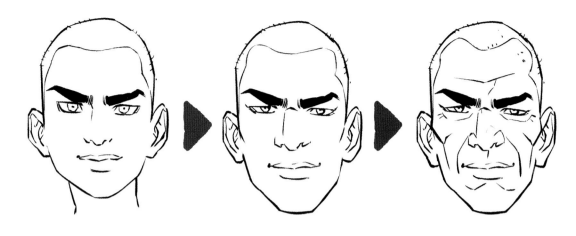

As noted earlier, for most semirealistic to realistic art styles as well as in real life, the heads of kids tend to be rounder than adults' and have pointier jaws. Their eyes and cheeks may be slightly fuller. As the aging process takes its course, we get more wrinkle lines as well as lines that show the bony structure of the face. The hairline may recede, or a character may be completely bald.

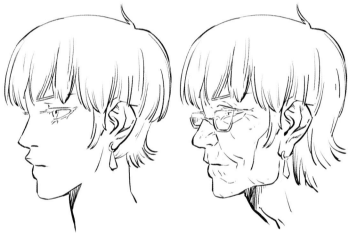

Missing or crooked teeth are also a possible feature. The skin on the face, eyelids, and ears may droop a bit. The more lines you use to show wear on the face, the older the character looks. Feel free to add accessories like eyeglasses to show loss of sight, which also signals and symbolizes change for the character, which is part of aging.

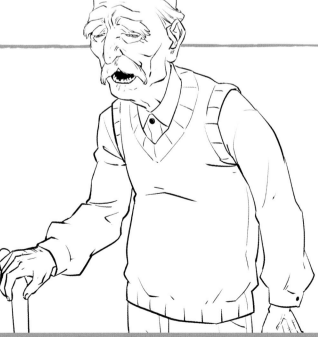

Outside of a few exceptions, the structure of an adult figure is not much different from that of an elderly figure, but having the character be a bit hunched over or use a cane for mobility can help sell the aged look.

HANDS

FOLLOW THIS BASIC EXPLANATION TO DRAW YOUR CHARACTER'S HANDS, REFERRING TO THE GESTURES HERE AS EXAMPLES. KEEP TRACK OF WHICH FINGERS ARE TALLER AND THICKER THAN OTHERS FOR INSTANCE, THE MIDDLE FINGER IS USUALLY THE TALLEST, FOLLOWED BY THE INDEX FINGER. THE PINKY IS THE SHORTEST AND THINNEST, WHILE THE THUMB IS THE THICKEST. TO GET USED TO THE PROPORTIONS ON A HAND, WE'LL USE SIMPLE SHAPES TO ESTABLISH THE PROPORTIONS FIRST.

1

Start with a crossed box.

2

Add triangular shapes for the fingers and then use simple lines to separate the fingers.

3

Use these shapes to form the organic lines for the hand.

Note the motion of the fingers, their limits, and how they stretch and fold outward and inward respectively.

Feel free to reference your own hand while drawing for authenticity.

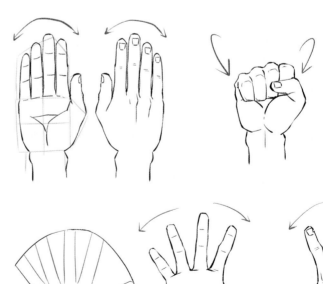

FEET

FOLLOW THIS BASIC EXPLANATION TO DRAW YOUR CHARACTER'S FEET, REFERRING TO THE GESTURES HERE AS EXAMPLES. KEEP TRACK OF WHICH TOES ARE TALLER AND THICKER THAN OTHERS - THE TOES GET SHORTER AND THINNER FROM THE BIG TOE TO THE PINKIE.

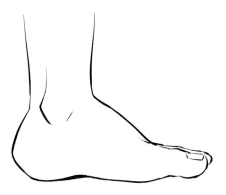

1

Start with a simple shape for the ankle and foot.

2

Add more shape to form the rest of the foot.

3

Render the lines in an organic way to form the foot. Feel free to reference images of real feet.

The same approach applies to drawing the feet from the front, as we did when constructing the body.

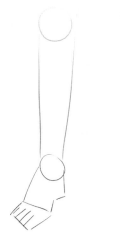
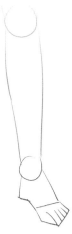
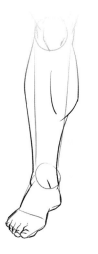

HERE ARE A FEW COMMON HAND GESTURES AND FOOT POSITIONS YOU'RE PROBABLY GOING TO FIND YOURSELF DRAWING OFTEN. START BY PRACTICING THESE GESTURES, THEN TWEAK AND MAKE ADJUSTMENTS TO LEARN MORE AS YOU GET COMFORTABLE.

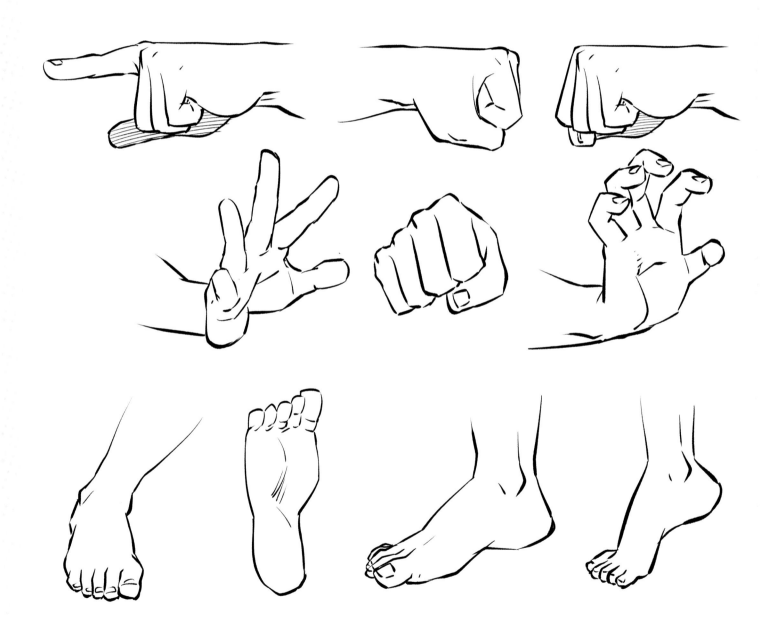

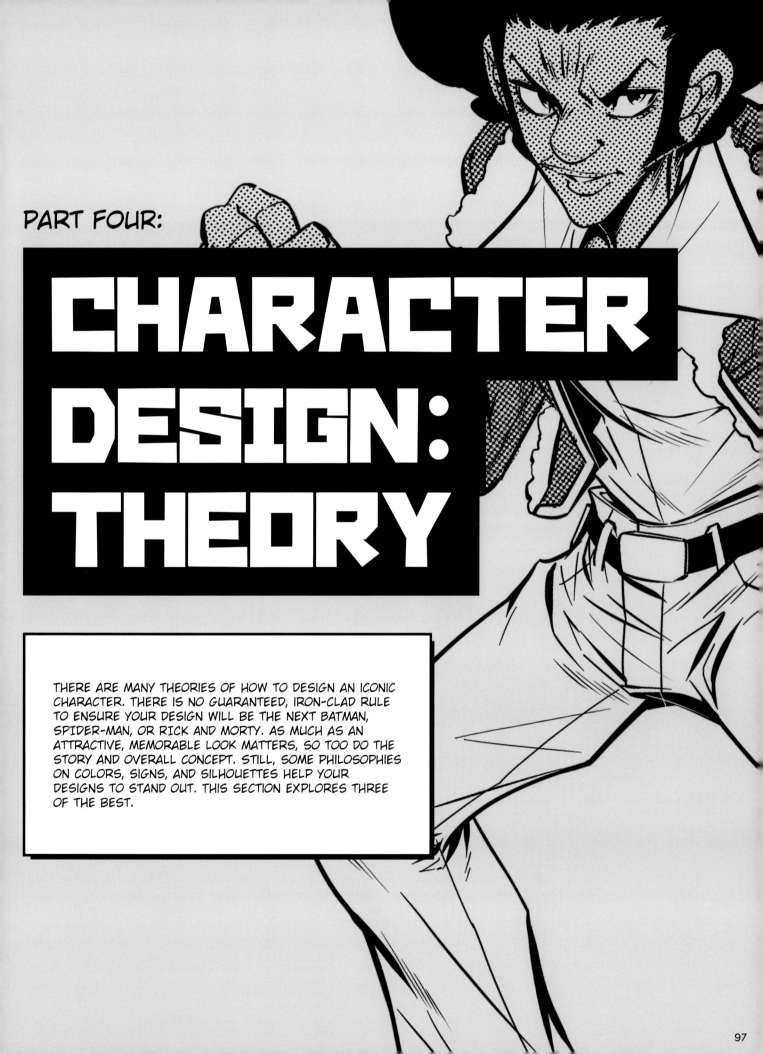

PART FOUR:

CHARACTER DESIGN: THEORY

THERE ARE MANY THEORIES OF HOW TO DESIGN AN ICONIC CHARACTER. THERE IS NO GUARANTEED, IRON-CLAD RULE TO ENSURE YOUR DESIGN WILL BE THE NEXT BATMAN, SPIDER-MAN, OR RICK AND MORTY. AS MUCH AS AN ATTRACTIVE, MEMORABLE LOOK MATTERS, SO TOO DO THE STORY AND OVERALL CONCEPT. STILL, SOME PHILOSOPHIES ON COLORS, SIGNS, AND SILHOUETTES HELP YOUR DESIGNS TO STAND OUT. THIS SECTION EXPLORES THREE OF THE BEST.

SEMIOTICS

SEMIOTICS STUDIES SIGNS OR SIGN PROCESSES AND SUGGESTS THAT INTENTIONAL OR UNINTENTIONAL IMAGERY CAN ADD MEANING TO YOUR ART. BATMAN'S DARK COWL AND LARGE POINTY EARS INDICATE THAT HE IS ONE TO BE FEARED. COMPARE THAT TO THE COLORFUL GI THAT GOKU WEARS IN DRAGON BALL, WHICH EVOKES A FRIENDLY CHARACTER WHO LOVES TO FIGHT.

WITH THE RIGHT BALANCE OF SHAPES, STYLES, AND MATERIALS, A GOOD OUTFIT AND BODY DESIGN CAN REVEAL A LOT ABOUT YOUR CHARACTER'S TIME, PLACE, CULTURE, AND PERSONALITY. DANTE ALFONSE FROM SATURDAY AM'S SERIES SOUL BEAT IS AN EXCELLENT EXAMPLE: WITH HIS AFRO, BRIGHT COLORS, AND SIGNIFICANT HEIGHT, DANTE SEEMS LIKE A LIKABLE CHARACTER WHO IS CONFIDENT IN A FIGHT. THIS SECTION WILL SHOW HOW WE CAN CHANGE HOW HE IS PERCEIVED JUST BY ALTERING HIS CLOTHING.

VERSION 1:
"DISCO DANTE"

SOUL BEAT is about a man trying to escape a fate in Hell. It began as "Dante's Disco Inferno," in which many characters, including Dante Alfonse himself, would have outfits you'd see out on the '70s dance floor: oversized lapels, big shoes, big Afro... Basically everything disco! But as the creator, Morganne Walker, continued to refine the idea, this design felt more like a caricature. The outfits, meant for dancing, were just too flashy—she described them as "feeling like a cheap Halloween costume"—and overshadowed other facets of the ccharacter's personality and the seriousness of the story. So while Dante (like his creator) still loves the classic '70s aesthetic, it not only doesn't solely define the protagonist but also doesn't fit the gravity of the story.

VERSION 2:
"TOUGH DANTE"

This design is less disco dancing and more ass-kicking! Taking inspiration from the "blaxploitation" movies of the '70s like SHAFT and CLEOPATRA JONES, and modern incarnations like BLACK DYNAMITE, the look involves a tactical turtleneck and imposing trench coat. With his accessories—leather gloves, army boots, dark sunglasses, weaponry—Dante's look here implies a hardened character in a deadly situation. This design is certainly more appropriate for someone trying to survive the forces of Hell that are coming after him. However, the stern expression and mature hairstyle also age Dante noticeably (he's supposed to be in his mid-20s) and make him look too confident in his abilities. In a way, this appearance comes off as invulnerable instead of a typical shōnen/shōjo hero with a sense of humor and room to grow.

"REAL DANTE"

The final design featured in SOUL BEAT is a more balanced mix of the two previous looks that meshes nicely with the original premise of the story (i.e., a man who saves his soul... with SOUL!). The lapels and flared pant legs connect back to the '70s aesthetic, along with Dante's classic Afro Morganne chose pastel colors to help soften his character and reveal a charming personality fit for a shōnen/shōjo hero. The always-cool bomber jacket, fighting pose, and smirking expression show Dante knows how to defend himself, just like other strong Black protagonists that he emulates.

WHY COSTUME DESIGN IS IMPORTANT

As stated earlier, creating an ICONIC CHARACTER LOOK is extremely difficult. Creating a functional outfit that FITS the character and is comfortable to draw is ideal for any artist.

One area that does require focus is representation. In '80s Hollywood movies, it was rare to see women as anything more than damsels in distress or minorities as anything beyond sidekicks or bad-guy henchmen.

Depictions of Asian characters speaking in broken English and being kung-fu fighters or perpetual tourists have aged poorly. Similarly, Black men have appeared in films both in Japan and in the US as tank-top-wearing ex–gang members. Middle Eastern characters as turban-sporting terrorists are unfortunately familiar tropes that feed negative perceptions.

Implicit in using SEMIOTICS as a theory is ensuring that your choices do not perpetuate stereotypes or prejudices that undermine your character and story.

SHAPE LANGUAGE

ARTISTS CAN USE SHAPES AND LINES AS A VISUAL LANGUAGE IN CHARACTER DESIGN BECAUSE SUBCONSCIOUSLY, WE ASSOCIATE SPECIFIC SHAPES WITH DIFFERENT MEANINGS. IN THIS SECTION, WE SHOW HOW YOU CAN EMPLOY THESE CONCEPTS FOR YOUR HEROES AND VILLAINS.

Artists can use shapes and lines as a visual language in character design. Subconsciously, we associate specific shapes with different meanings. In this section, we show how you can employ these concepts for your heroes and villains.

SQUARE

Reliable, trustworthy, uniform, traditional

CIRCLE

Harmless, charismatic, bubbly, endearing

TRIANGLE

Cunning, sharp, aggressive, dynamic

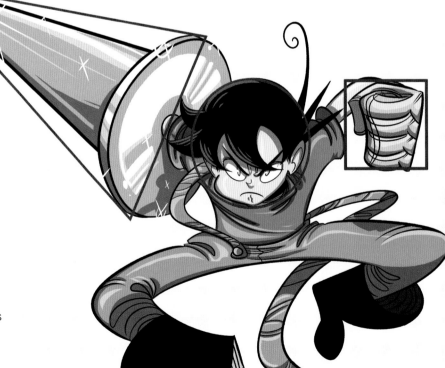

You can see how JeyOdin, in his hit manga series HAMMER, uses these three shapes in this particular action pose for the character Stud.

This attack is Stud's Nail Arm; it's representing a triangular shape, very sharp and aggressive.

Stud's face, usually very happy and friendly, is a circle, representing his bubbly personality and charismatic charm.

Lastly, the fist represents a square that looks very sturdy and reliable.

SILHOUETTE TEST

THE SILHOUETTE TEST IS A STANDARD TEST THAT MOST SUCCESSFUL CHARACTER DESIGNS PASS. IS YOUR CHARACTER SO DISTINCTIVE THAT THEY CAN EVENTUALLY BE RECOGNIZED SOLELY FROM THEIR SILHOUETTE IN THEIR GO-TO POSE? IF YES, THEN THE DESIGN PASSES; IF NO, THEN YOU MAY WANT TO DRAFT MORE ITERATIONS OF YOUR CHARACTER TILL YOU FEEL IT GIVES.

PASSING THE SILHOUETTE TEST IS USUALLY EASIER IF THE SHAPE LANGUAGE OF THE DESIGN IS ALSO READABLE IN SILHOUETTE ALONE.

COMPARE THE SILHOUETTED SATURDAY AM CHARACTERS WITH THEIR FULL-COLOR VERSIONS BELOW. SEE HOW THEY EACH HAVE UNIQUE SIZES, SHAPES, AND BODY LANGUAGE TO MAKE THEM ALL DISTINCT.

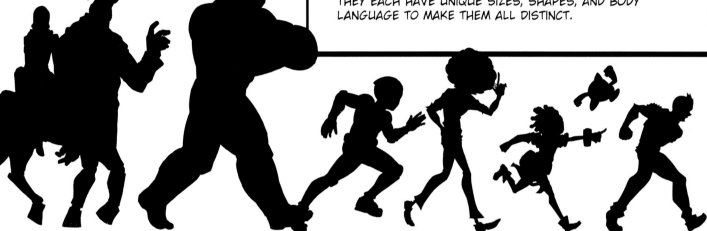

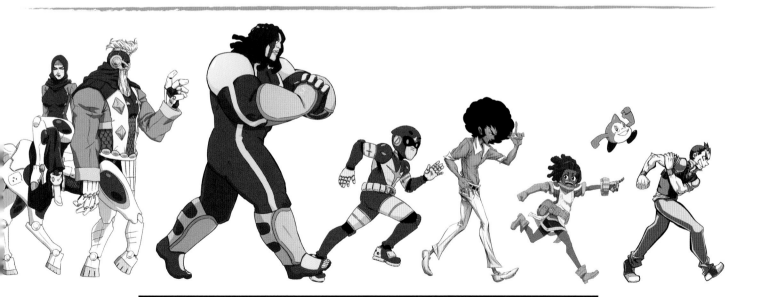

PRACTICE THE SILHOUETTE TEST WITH YOUR CHARACTERS TO MAKE SURE THEY'RE IDENTIFIABLE AND UNIQUE.

SKIN TONES

SENSITIVITY IN DRAWING BLACK FACES AND SKIN TONES

THE USE OF COLOR TO DENOTE PERSONALITIES OR QUALITIES WITHIN YOUR WORK IS CALLED COLOR THEORY. THIS SECTION COVERS THE COMPLICATED STRATEGY FOR ACCURATELY DEPICTING SKIN TONES ON ETHNIC CHARACTERS. ULTIMATELY, IT'S A CREATIVE DECISION OF ANY ARTIST. STILL, WE WILL FOCUS EXCLUSIVELY ON PEOPLE OF AFRICAN DESCENT TO DEMONSTRATE THE PITFALLS OF STEREOTYPING (OR WORSE YET, ERASING) AN ETHNIC CHARACTER'S IDENTITY. COLORISM IS A REAL ISSUE WITHIN ENTERTAINMENT AS LIGHTER-SKINNED CHARACTERS ENJOY A STATUS THAT SUGGESTS THEY ARE MORE INTELLIGENT AND LIGHTHEARTED THAN DARKER-SKINNED. READ BELOW TO GET THREE DIFFERENT OPINIONS FROM SOME OF SATURDAY AM'S MOST PROMINENT BLACK ARTISTS.

PAP SOULEYE FALL ARTIST OF OBLIVION ROUGE:

Skin tones are such a fun area for me! Working with Black characters allows for a real range of color. It's important to look at the way light effects the skin it helps understand the spectrum. If you're drawing a darker skin tone think about the way light reflects off of darker skin. There's also something really beautiful about the way you can go from really dark to really light. It's important to also think about the base color for the skin tone. Black skin is usually either in blue, red, orange, and yellow. For the shading focus on using complimentary colors based on the color you chose for the skin tone.

CHARACTERS FROM PAP SOULEYE FALL'S SERIES *OBLIVION ROUGE*

WHYT MANGA'S *BACASSI* SERIES FEATURES SEVERAL AFRICAN PROTAGONISTS OF DIFFERENT SKIN COMPLEXIONS, INCLUDING ALIEN CULTURES.

ISSAKA GALADIMA ARTIST OF *CLOCK STRIKER*

One reason I like coloring black-skinned characters is that the skin color can vary a lot. It can be very light or dark, peanut butter or chocolate, cool or warm. This brings tons of variant brown you can use. As for choosing them, it depends on you and the kind of character you want to make. Give it a try and see how you like it. If you are coloring digitally, remember to desaturate it a bit (I'd recommend staying under 50%) to make the character's skin feels natural. And for the shading, you can use dark pink on a semitransparent layer with the blending mode set to multiply. It works well with most skin tones.

CHARACTER DESIGN: GALLERY

NOW THAT YOU REVIEWED THE THEORIES ON CHARACTER DESIGN, IT'S TIME TO LOOK AT SOME SPECIFIC EXAMPLES OF CRAFTING ORIGINAL CHARACTERS. IN THIS SECTION, YOU WILL SEE A COMBINATION OF BOTH NEW AND EXISTING CHARACTERS. WE BELIEVE THAT ARTISTS WILL ENJOY THIS APPROACH TO SHOW HOW WE CRAFTED OUR HEROES AND INSPIRE YOU TO TRY AND CREATE YOUR OWN!

CREATING SATURDAY AM CHARACTERS:

THE STRIKERS

BY ISSAKA GALADIMA

CLOCK STRIKER IS ONE OF SATURDAY AM'S MOST POPULAR SERIES AND HOLDS THE DISTINCTION OF SHONEN MANGA'S FIRST BLACK FEMALE LEAD CHARACTER. THE BELOVED SERIES HAS MANY FANS DUE TO THE KICK-ASS PROTAGONIST, CAST – A STRIKER, OR TRAINEE, UNDER MS. PHILOMENA CLOCK, A SMITH. THE FRATERNAL ORDER OF SMITHS IS A FEDERATION OF WORLD-TRAVELING MIGHTY WARRIORS WHO ARE ALSO ENGINEERS. THESE HEROES CAN BUILD THINGS OR THEY CAN DESTROY THEM, AND PEOPLE EVERYWHERE ADORE THEM.

IN THE LATEST CHAPTERS OF CLOCK STRIKER, READERS CAN SEE THAT WE ARE INTRODUCING MORE STRIKERS À LA CAST. THEY ARE JAKARI, THE BEAST STRIKER, AND REVA, THE BLIND STRIKER.

REVA IS A PURPLE SMITH-CLASS STRIKER, WHICH MEANS SHE SPECIALIZES IN SOCIAL ENGINEERING. HER ROBUST CODE ALLOWS HER TO USE HOLOGRAPHIC PROJECTION TO CHANGE HER APPEARANCE TO LOOK LIKE ANYONE SHE CHOOSES.

JAKARI IS AN ORANGE SMITH-CLASS STRIKER, WHICH MEANS HE SPECIALIZES IN BIOENGINEERING. HIS GAUNTLETS TRIGGER DNA SEQUENCING, WHICH CAN ENHANCE HIS SPEED AND STRENGTH.

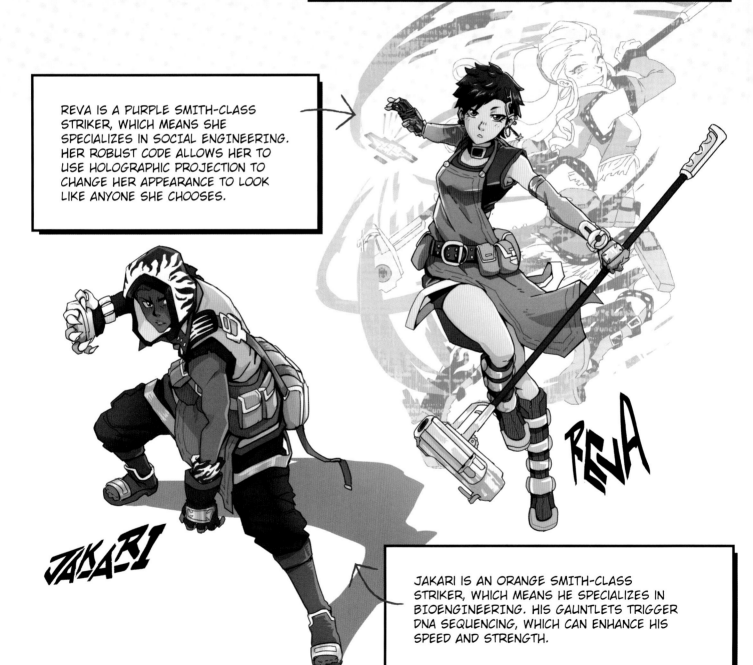

CREATING A STRIKER: ANGEL

STEP 1: SCRIPT

Write three sentences that sum up WHO your character is in terms of personality, culture, and role in the story.

EXAMPLE:

- Angel is a determined and hardworking fighter who manipulates plants.
- She comes from a noble and traditional family that handles war strategy.
- She's from a fictional country inspired by Southeast Asia.

STEP 2: GLOBAL ASPECT

Sketch four different versions in different postures to have a better glimpse of your character, then choose the one that fits the best. In this example on the right, Issaka chose option B.

Now that you have a clearer idea of your character, you can start working on the details.

A FIGHTER

B MILITARY

C OPTIMAL

D TRADITIONAL

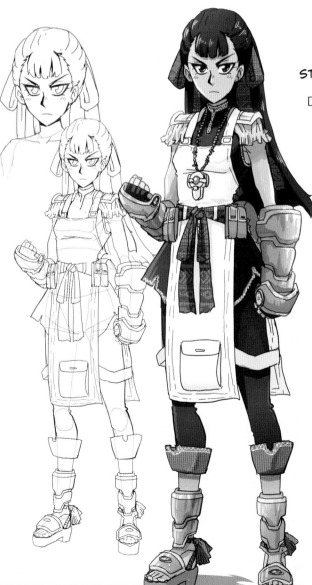

STEP 3: FACE AND HAIR

Decide what type of face and hair you want your character to have.

In this example , Angel has a stern face and a pose that shows that she is always ready to fight. It illustrates her martial artist and serious side.

STEP 4: CLOTHES

Now add the clothes. As Angel is a martial artist, Issaka also added gauntlets to her design.

STEP 5: COLORS

Add the colors. In this example, blue was chosen as the main color and pink for the secondary color. They were inspired by some Southeast Asian cultures (notably the Hmong people, who dress in a lot of pink and blue).

STEP 6: PATTERNS AND SECONDARY ACCESSORIES

Congratulations! Most of the work is complete. This step is optional, but it will bring more depth to the design. Here is where you add the jewelry, tattoos, patterns, scars, and other distinctive details. In this example, Issaka added patterns on the textiles (also inspired by Southeast Asia) and a bead necklace to show more of her traditional side.

For a more "finished" look, you can add shadows and lights.

Well done. Your character is now ready to jump into your DIVERSE comic!

GUNHILD

BY FRED TORNAGER

THIS SMALL, CUTE, AND BADASS
LITTLE LADY IS THE STAR OF GUNHILD
(PUBLISHED WITHIN SATURDAY
AM SPINOFF MAGAZINE *SATURDAY
BRUNCH*). SHE IS A FLAME-WIELDING
BEING FROM MUSPELHEIM WHO
WISHES TO GAIN RESPECT BY
BECOMING A DEMIGOD À LA THOR AND
LOKI. WHILE SHE IS HOT-TEMPERED BY
NATURE, GUNHILD DOES HAVE A SOFT
SPOT FOR PEOPLE AND TRAVELS WITH
HER BEST FRIEND, NEWTON THE FIRE
SALAMANDER.

IT'S IMPORTANT TO DEPICT GUNHILD
AS A FUN CHARACTER DESPITE HER
TEMPER.

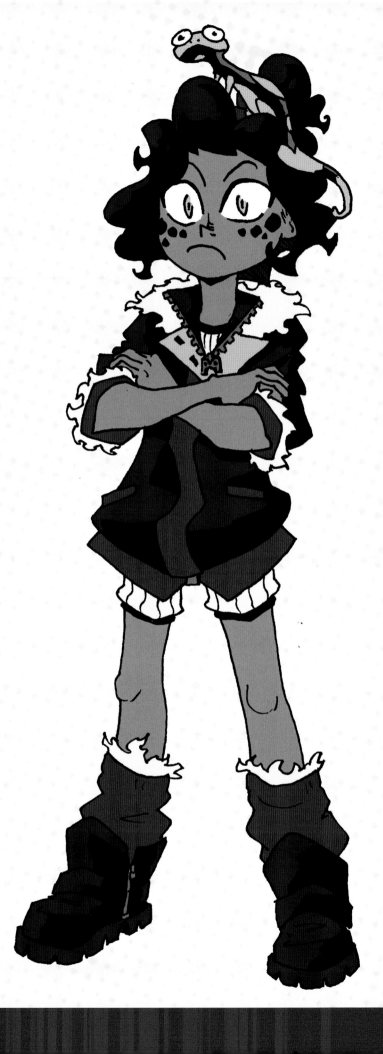

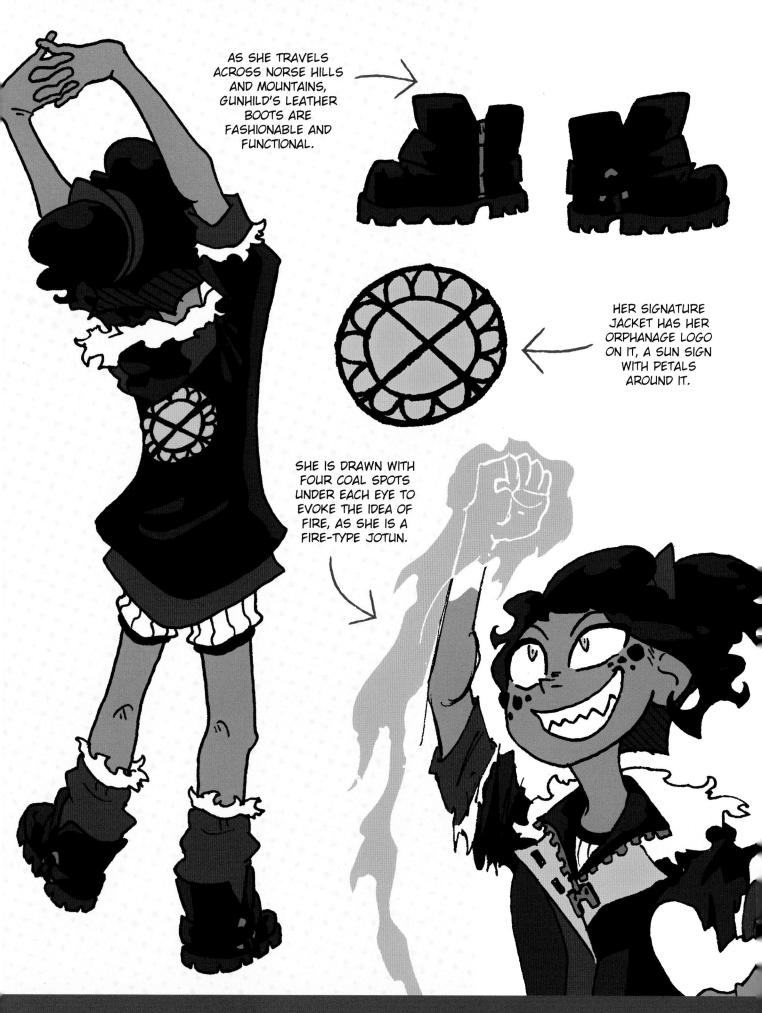

AS SHE TRAVELS ACROSS NORSE HILLS AND MOUNTAINS, GUNHILD'S LEATHER BOOTS ARE FASHIONABLE AND FUNCTIONAL.

HER SIGNATURE JACKET HAS HER ORPHANAGE LOGO ON IT, A SUN SIGN WITH PETALS AROUND IT.

SHE IS DRAWN WITH FOUR COAL SPOTS UNDER EACH EYE TO EVOKE THE IDEA OF FIRE, AS SHE IS A FIRE-TYPE JOTUN.

THOR

BY FRED TORNAGER

THE GOD OF THUNDER IS WELL KNOWN WORLDWIDE THANKS TO MARVEL'S THOR COMICS AND CHRIS HEMSWORTH'S PORTRAYAL IN THE MOVIE ADAPTATIONS. HOWEVER, THE CLASSIC VERSION FROM NORSE MYTHOLOGY IS QUITE DIFFERENT, WITH RED HAIR AND BEHAVING RATHER BOASTFULLY.

THE VERSION OF THOR IN GUNHILD, WHICH IS A COMEDIC ACTION SERIES, IS BROAD, PROUD, AND STRONG. WHILE NOT THE BRIGHTEST BEING, THIS VERSION OF THE THUNDER GOD SHOWCASES HIM AS A WRY OLDER FIGURE WHO RECOGNIZES GUNHILD'S POTENTIAL.

THOR'S SIGNATURE LOOK INCLUDES HIS RED BEARD AND BELOVED HAMMER CALLED MJOLNIR, WHICH ALSO CARRIES HIS LOGO. AS THIS CHARACTER HAS BEEN SO WELL DEPICTED IN PREVIOUS MEDIA, THIS VERSION IS AN OLDER VERSION OF THE HERO. THE DESIGN, THEREFORE, WENT WITH SOME NEW ELEMENTS, SUCH AS A SHOCK OF WHITE HAIR, STUDS ON HIS EXTREMITIES AND BELTS, AND TATTOOS ACROSS HIS BODY CELEBRATING HIS MANY ADVENTURES.

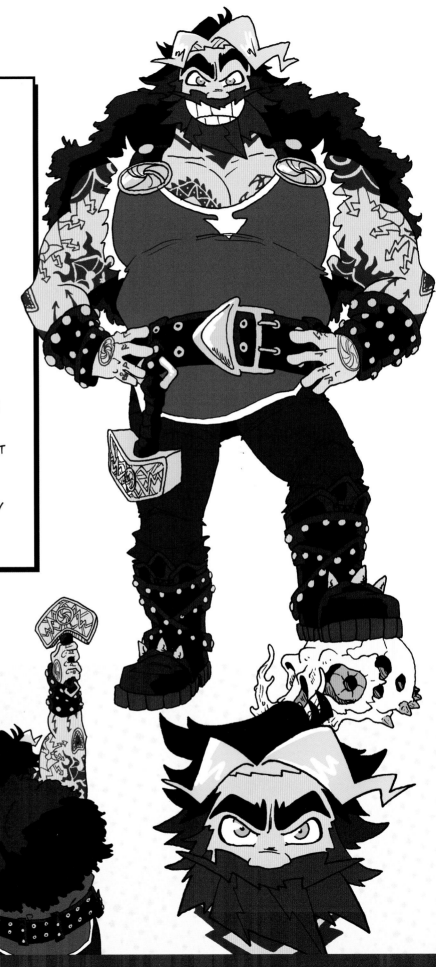

LOKI

BY FRED TORNAGER

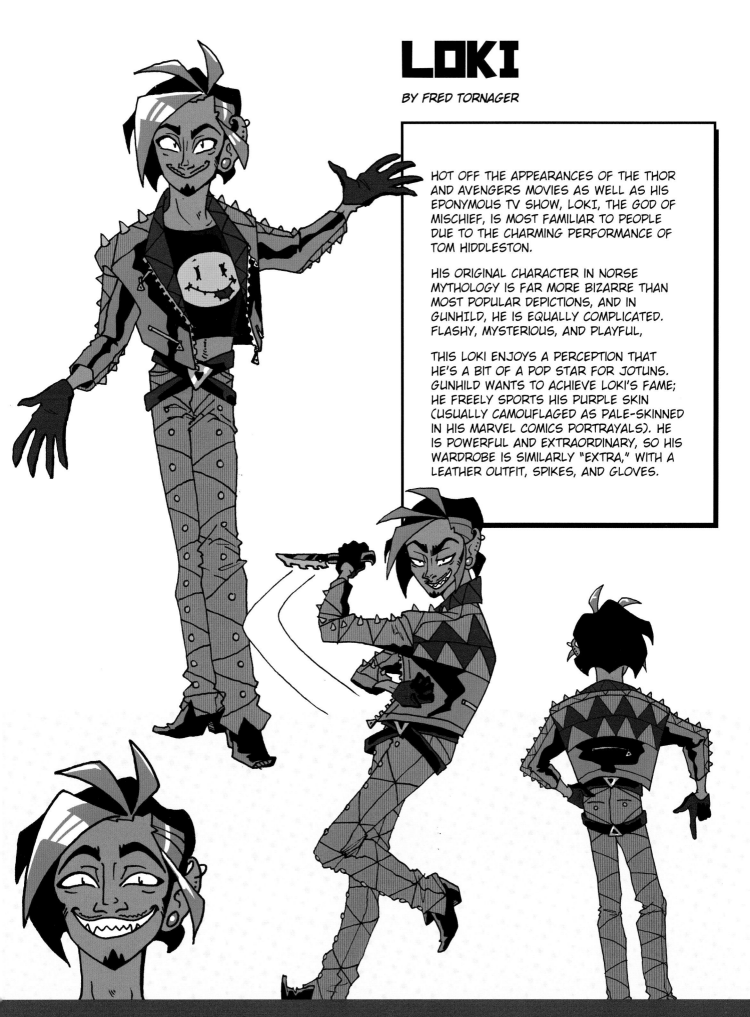

HOT OFF THE APPEARANCES OF THE THOR AND AVENGERS MOVIES AS WELL AS HIS EPONYMOUS TV SHOW, LOKI, THE GOD OF MISCHIEF, IS MOST FAMILIAR TO PEOPLE DUE TO THE CHARMING PERFORMANCE OF TOM HIDDLESTON.

HIS ORIGINAL CHARACTER IN NORSE MYTHOLOGY IS FAR MORE BIZARRE THAN MOST POPULAR DEPICTIONS, AND IN GUNHILD, HE IS EQUALLY COMPLICATED. FLASHY, MYSTERIOUS, AND PLAYFUL,

THIS LOKI ENJOYS A PERCEPTION THAT HE'S A BIT OF A POP STAR FOR JOTUNS. GUNHILD WANTS TO ACHIEVE LOKI'S FAME; HE FREELY SPORTS HIS PURPLE SKIN (USUALLY CAMOUFLAGED AS PALE-SKINNED IN HIS MARVEL COMICS PORTRAYALS). HE IS POWERFUL AND EXTRAORDINARY, SO HIS WARDROBE IS SIMILARLY "EXTRA," WITH A LEATHER OUTFIT, SPIKES, AND GLOVES.

BLAZE

BY BON IDLE

BLAZE IS THE MAIN CHARACATER OF *HENSHIN!*, A SUPER SENTAI-INSPIRED SERIES IN SATURDAY AM SPINOFF MAGAZINE, *SATURDAY BRUNCH.*

BLAZE'S ARMOR TAKES VISUAL CUES FROM A WIDE RANGE OF TV SHOWS, PRIMARILY JAPANESE SHOWS *CHŌJIN SENTAI JETMAN*, *ULTRAMAN* AND OF COURSE, *MIGHTY MORPHIN' POWER RANGERS.*

AS THE PHOENIX HERO, HIS ABILITIES ARE FIRE-BASED, AND HE IS THE LEADER OF HIS TEAM, SO FOLLOWING GENRE TROPES HIS ARMOR IS RED. BON IDLE USED A COMPLIMENTARY WARM YELLOW FOR THE BEAK ON HIS HELMET AND COLLAR. HE APPLIED THE SAME COLOR TO THE GROOVES ON BOTH SIDES OF HIS MOUTHGUARD TO HELP TIE EVERYTHING TOGETHER. THE REST OF HIS ARMOR IS EITHER RED OR SHINY METAL.

THE REST OF HIS ARMOR IS EITHER RED OR A SHINY METAL.

ALL THE ARMORED CHARACTERS IN HENSHIN! USE SOMETHING CALLED SPIRIT ENERGY. FOR THE HEROES, THIS ENERGY IS A BRIGHT BLUE-GREEN COLOR. THEIR ENEMIES, THE KAIJU MONSTERS AND OMEN (ON THE RIGHT), HAVE THE OPPOSITE COLOR: BRIGHT PINK. THIS CONTRAST HELPS TO REINFORCE THEIR OPPOSING POSITIONS BUT ALSO DIFFERENTIATES THEIR POWERS IN COLOR ARTWORK.

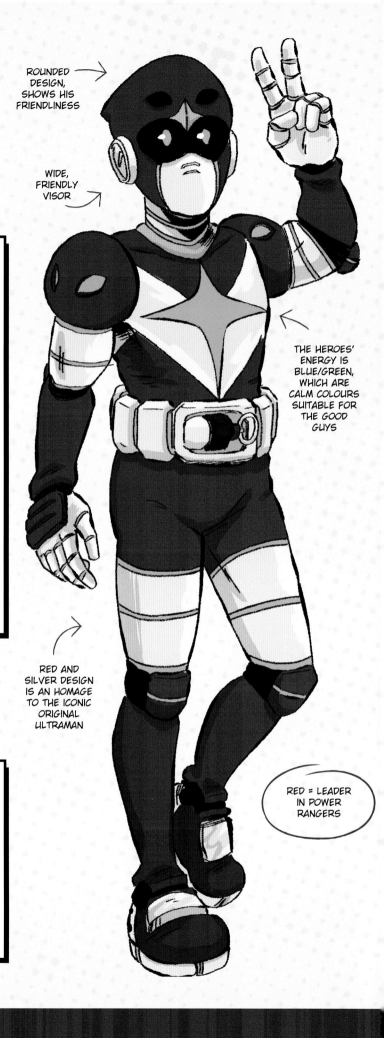

ROUNDED DESIGN, SHOWS HIS FRIENDLINESS

WIDE, FRIENDLY VISOR

THE HEROES' ENERGY IS BLUE/GREEN, WHICH ARE CALM COLOURS SUITABLE FOR THE GOOD GUYS

RED AND SILVER DESIGN IS AN HOMAGE TO THE ICONIC ORIGINAL ULTRAMAN

RED = LEADER IN POWER RANGERS

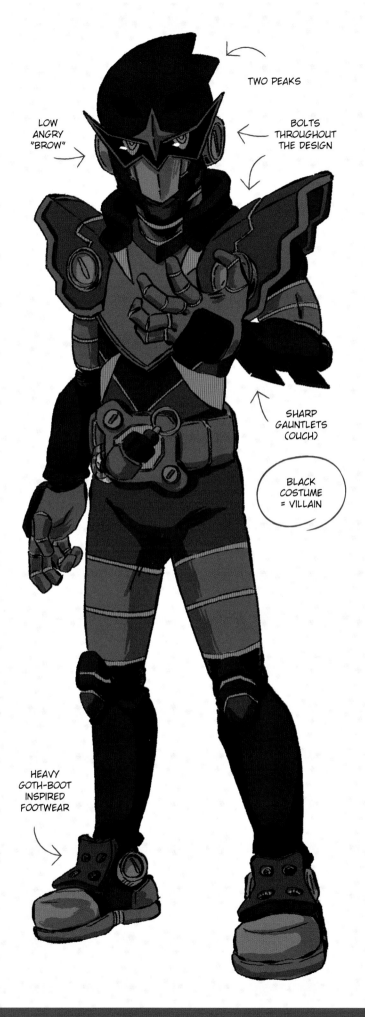

TWO PEAKS

LOW ANGRY "BROW"

BOLTS THROUGHOUT THE DESIGN

SHARP GAUNTLETS (OUCH)

BLACK COSTUME = VILLAIN

HEAVY GOTH-BOOT INSPIRED FOOTWEAR

OMEN

BY BON IDLE

THE MYSTERIOUS CHARACTER OMEN'S ARMOR IS A HEAVY-DUTY AND MORE ANGULAR VERSION OF BLAZE'S.

HE IS ALSO BIRD THEMED (A RAVEN), SO HIS HELMET HAS A SIMILAR DESIGN, BUT WITH AN ANGLED VISOR EXTENDING OFF THE SIDES, A POINTED MOUTHGUARD, AND TWO PEAKS ON THE BACK OF THE HELMET. HIS SHOULDER ARMOR IS ALSO POINTED AND SLOPING UPWARD, GIVING HIM A MORE ANGULAR AND THREATENING SILHOUETTE. AS THE SECOND ARMORED CHARACTER TO APPEAR IN THE SERIES, HE ALSO HAS SEVERAL ELEMENTS IN HIS DESIGN THAT ARE IN PAIRS OR SPLIT INTO HALVES, SUCH AS THE BOLTS ON HIS SHOULDERS, HIS BELT, ANKLES, AND HIS KNEE AND ELBOW ARMOR.

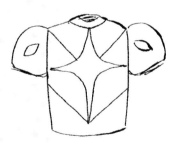 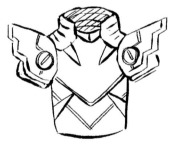

BOTH CHARACTERS ALSO HAVE UNIQUE DETAILS ON THEIR ARMOR THAT SIGNIFY THEIR TEAM OR ALLEGIANCE, SUCH AS THE CROSS ON BLAZE'S CHEST AND THE NEGATIVE CROSS AROUND OMEN'S.

NILAY RAO

BY OSCAR FONG

NILAY RAO IS THE MAIN CHARACTER WITHIN THE SATURDAY AM SERIES MASSIVELY MULTIPLAYER WORLD OF GHOSTS (MMWOG FOR SHORT). IN THIS SECRET WORLD, PEOPLE ("PLAYERS") CAN CONTROL EXTRADIMENSIONAL BEINGS CALLED GHOSTS AND SUMMON THEM IN BATTLES HIDDEN MAINLY FROM THE REAL WORLD. AS A ROOKIE PLAYER, NILAY IS BASED IN THE SMALL TOWN OF MORRISVILLE, NORTH CAROLINA, AND IS STILL LEARNING MUCH ABOUT THIS NEW WORLD WITH HIS TWO GHOSTS: THE MISCHIEVOUS ORANGE BEING VYPER NEO AND THE EIGHT-FOOT-TALL BLUE RAGE MONSTER DAEDALUS BONN.

BORN AND RAISED IN AMERICA, NILAY HAS A PASSION FOR PLAYING VIDEO GAMES, WATCHING BASKETBALL, AND EATING JUNK FOOD. HIS ATTIRE CONSISTS OF AN ANIME AND GAMING-INSPIRED HOODIE, SLIGHTLY BAGGY JEANS, AND ORDINARY TENNIS SHOES THAT ARE COMFORTABLE.

VYPER NEO

NILAY'S MAIN GHOST, VYPER NEO, IS A SPUNKY TRANSMOPRH. HE CAN CHANGE HIS SHAPE AND ABSORB ENERGY FROM NEARLY ALL LIVING THINGS. WE WANTED THE DESIGN TO SEEM SIMILAR TO ANY OLD SCHOOL VIDEO GAME MASCOT SO HE IS SHORT AND LOVABLE. THAT SAID, HIS PERSONALITY IS THAT OF A LOUD, MISCHIEVOUS KID - PERFECT AS A FRIEND TO NILAY.

DAEDALUS BONN

NILAY'S SECOND GHOST IS THE POWERFUL, ENIGMATIC DAEDALUS BONN. ALSO A TRANSMORPH, HE CAN TRANSFORM HIS APPENDAGES INTO GUNS, CANNONS, AND BLUNT FORCE WEAPONS. AT 8 FT (2.4 M) TALL, WE DESIGNED DAEDALUS BONN TO BE AN IMPOSING, FEAR-INDUCING ICON FOR THE SERIES AND THUS ELEMENTS THAT WILL HELP. HIS COLOR SCHEME IS AN EXAMPLE OF COLOR THEORY AS THE BLUE AND BLACK SEEMS OMINOUS AND THE DREADLOCKS OFFER A UNIQUE SILHOUETTE TEST THAT IS UNLIKE OTHER BIG COMIC CHARACTERS.

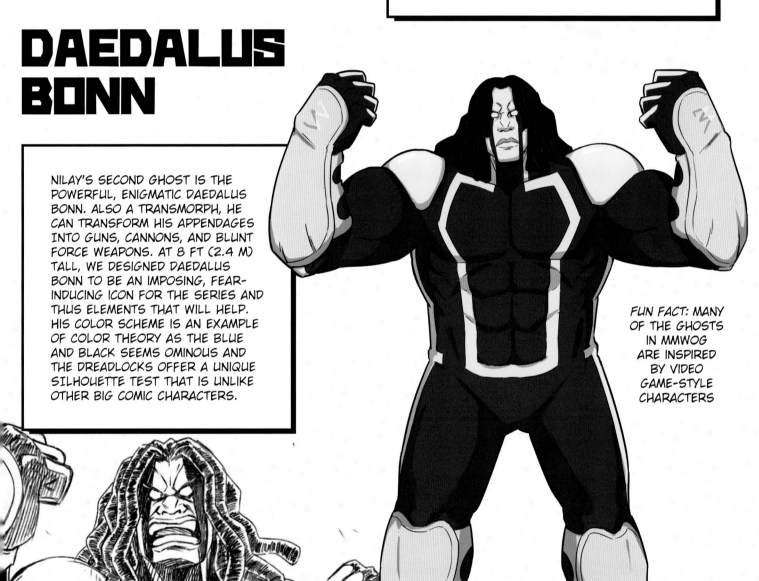

FUN FACT: MANY OF THE GHOSTS IN MMWOG ARE INSPIRED BY VIDEO GAME-STYLE CHARACTERS

DIA RAO

BY OSCAR FONG

DIA RAO IS THE MOTHER OF MASSIVELY MULTIPLAYER WORLD OF GHOSTS PROTAGONIST NILAY RAO AND IS A SENIOR "PLAYER" CAPABLE OF SUMMONING POWERFUL GHOSTS TO BATTLE HER OPPONENTS.

WHEN SHE UNCOVERS A CONSPIRACY, SHE SENDS HER UNSUSPECTING SON A POWERFUL TOOL TO BRING FORTH GHOSTS, HOPING THAT IT WOULD BE SAFE WITH HIM.

DIA WEARS A DRESS WITH A CHINTZ DESIGN MADE SHORT FOR BETTER MOBILITY AND A PAIR OF PANTS BECAUSE CHARACTERS TEND TO LOOK BETTER WHEN DRAWN RUNNING (WHICH SHE DOES A LOT) IN PANTS THAN IN SKIRTS.

DIA WEARS A SMALL DUPATTA, WHICH SHE CAN WEAR AS A MAKESHIFT SHAWL AND SCARF.

DIA IS A NATIVE OF KOLKATA, INDIA, AND HER DESIGN USES FASHIONABLE HINDU CULTURE WITH A MIX OF ACTIVEWEAR FOR HER OFTENTIMES DANGEROUS TRAVELS.

STEEL TUSK DURGA

STEEL TUSK DURGA IS ONE OF DIA RAO'S GHOSTS. AS THESE DIGITAL SPECTERS CAN LOOK LIKE ANYTHING (THERE IS NO "RACE" OR ETHNICITY FOR THEM), THIS 7 FT TALL CHARACTER DESIGN IS INSPIRED MAINLY BY THE HINDU GODDESS DURGA, KNOWN FOR STRENGTH AND POWER. THE MORE NOTABLE FEATURES ARE THE EIGHT ARMS AND WEAPONS SHE USES (DOWN FROM THE TEN DEPICTIONS TYPICALLY SHOW HER AS HAVING).

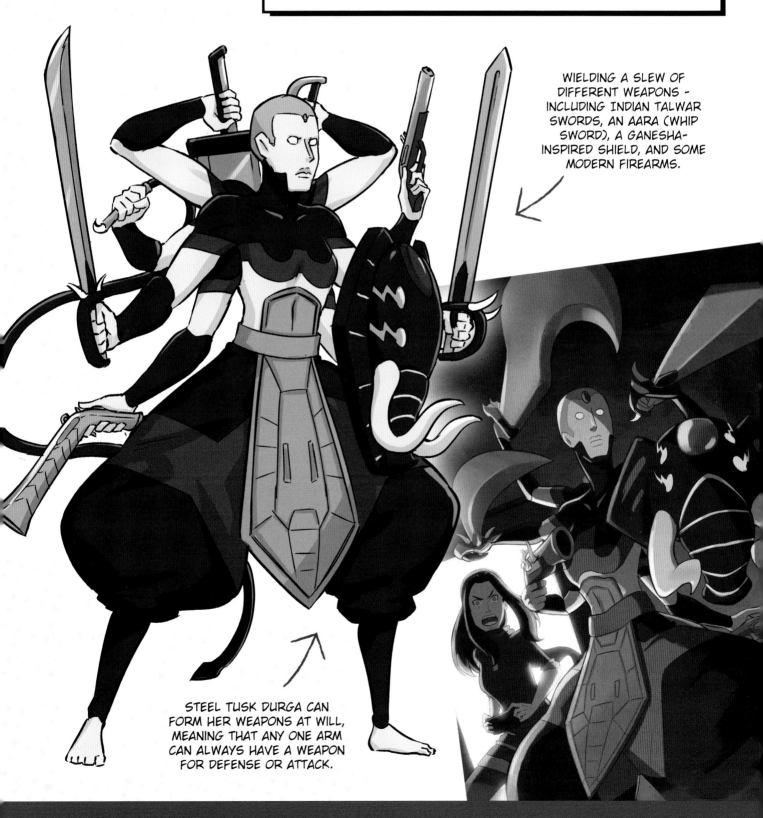

WIELDING A SLEW OF DIFFERENT WEAPONS - INCLUDING INDIAN TALWAR SWORDS, AN AARA (WHIP SWORD), A GANESHA-INSPIRED SHIELD, AND SOME MODERN FIREARMS.

STEEL TUSK DURGA CAN FORM HER WEAPONS AT WILL, MEANING THAT ANY ONE ARM CAN ALWAYS HAVE A WEAPON FOR DEFENSE OR ATTACK.

CREATING
NEW CHARACTERS:

JUN-SEO
THE
K-HYPE
BEAST

BY WHYT MANGA

THIS NEW CHARACTER DESIGN USES SHAPE LANGUAGE FOR ITS LOOK AND FEEL AND PASSES THE SILHOUETTE TEST.

JUN-SEO, THE K-HYPE BEAST, IS AN ORIGINAL DESIGN FOR THIS BOOK, OFFERING A NEW EAST ASIAN CHARACTER. BASED ON HIS CHARACTER DESIGN, YOU CAN SEE THE FUNDAMENTAL SHAPE OF A STAR INDICATING SUBCONSCIOUSLY THROUGH JUN-SEO'S POSE THAT HE IS UNIQUE IN SOME WAY, LIKE A KOREAN POP STAR. A STAR IS ALSO A COMBINATION OF TRIANGLES, SO CHARACTERS WITH THAT SHAPE WILL HAVE SOME OF THE CHARACTERISTICS FOUND IN THE SHAPE LANGUAGE OF TRIANGLES.

AS JUN-SEO IS SUPPOSED TO BE A MODERN CELEBRITY OF SOME SORT, WHYT MANGA WISELY BROUGHT MANY CURRENT SENSIBILITIES TO HIS OVERALL LOOK.

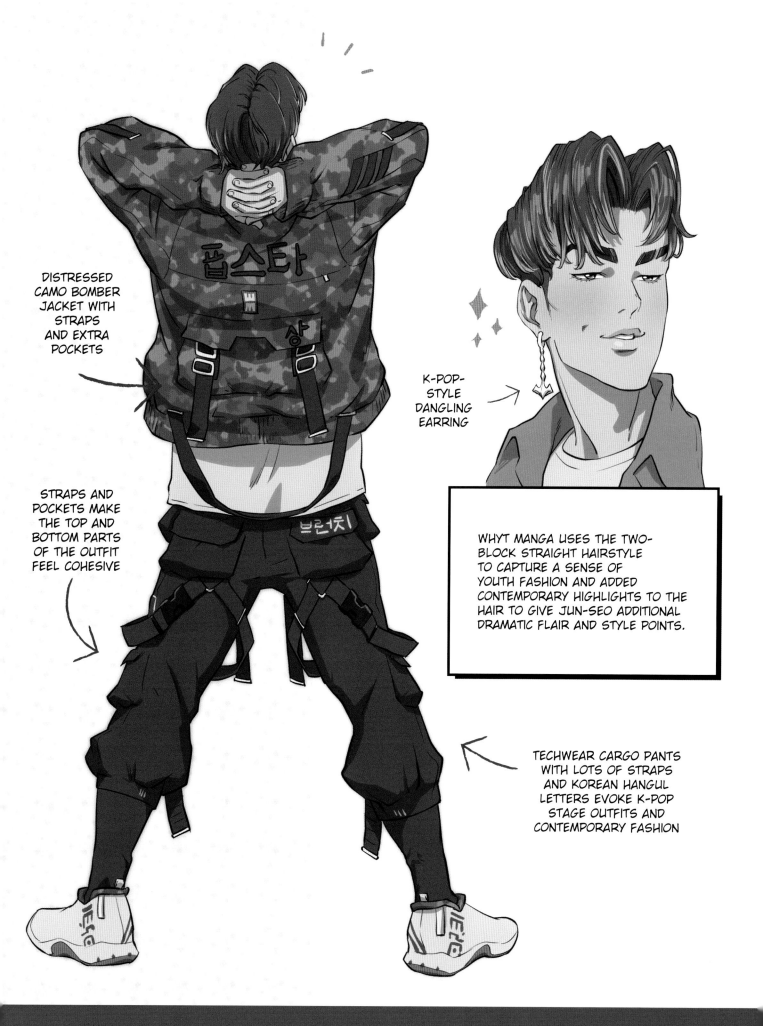

DISTRESSED CAMO BOMBER JACKET WITH STRAPS AND EXTRA POCKETS

STRAPS AND POCKETS MAKE THE TOP AND BOTTOM PARTS OF THE OUTFIT FEEL COHESIVE

K-POP-STYLE DANGLING EARRING

WHYT MANGA USES THE TWO-BLOCK STRAIGHT HAIRSTYLE TO CAPTURE A SENSE OF YOUTH FASHION AND ADDED CONTEMPORARY HIGHLIGHTS TO THE HAIR TO GIVE JUN-SEO ADDITIONAL DRAMATIC FLAIR AND STYLE POINTS.

TECHWEAR CARGO PANTS WITH LOTS OF STRAPS AND KOREAN HANGUL LETTERS EVOKE K-POP STAGE OUTFITS AND CONTEMPORARY FASHION

FRANKIE THE CYBER NINJA

BY WHYT MANGA

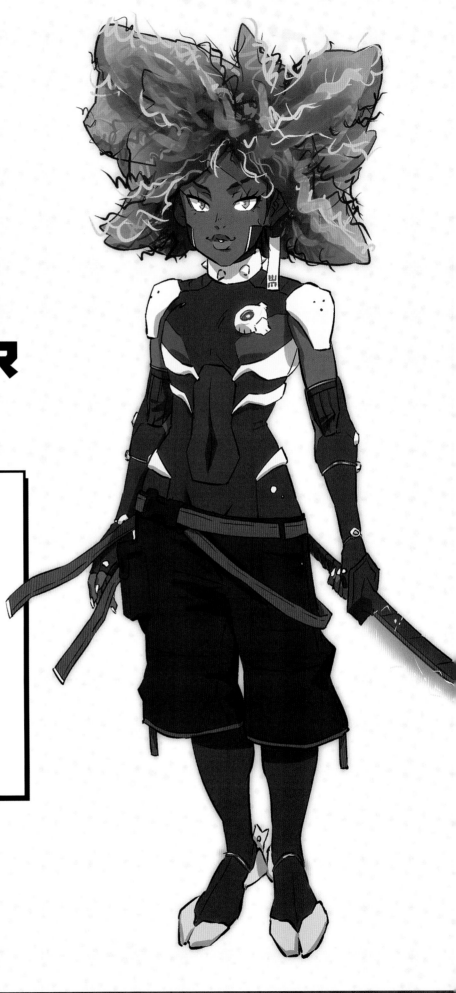

MEET FRANKIE CYMONE, AN ORIGINAL CHARACTER DESIGN BY WHYT MANGA. WE CAN TELL SHE IS A CYBORG AND A NINJA BASED ON HER CHARACTER DESIGN - FOR EXAMPLE, THE DESIGN SUGGESTS THAT PARTS OF HER BODY ARE CYBERNETIC. THE DIFFERENT SECTIONS ON HER FACE COULD MEAN SHE WAS EXPERIMENTED ON, FURTHER SIGNALING TO VIEWERS THAT SHE IS A CYBORG OF SOME KIND.

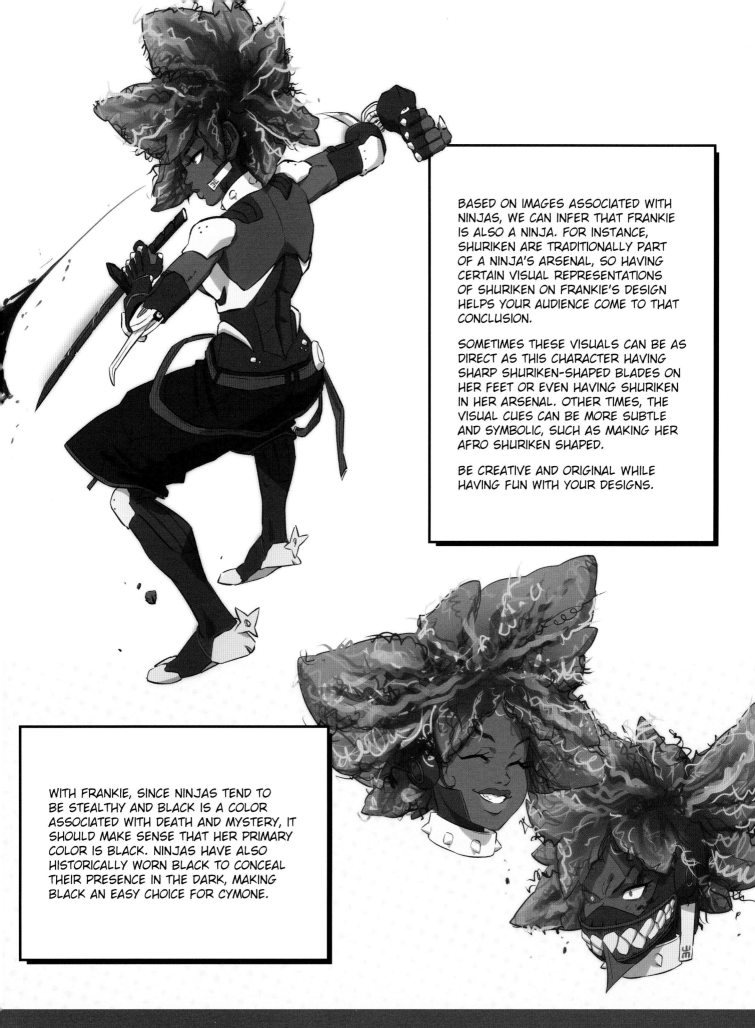

BASED ON IMAGES ASSOCIATED WITH NINJAS, WE CAN INFER THAT FRANKIE IS ALSO A NINJA. FOR INSTANCE, SHURIKEN ARE TRADITIONALLY PART OF A NINJA'S ARSENAL, SO HAVING CERTAIN VISUAL REPRESENTATIONS OF SHURIKEN ON FRANKIE'S DESIGN HELPS YOUR AUDIENCE COME TO THAT CONCLUSION.

SOMETIMES THESE VISUALS CAN BE AS DIRECT AS THIS CHARACTER HAVING SHARP SHURIKEN-SHAPED BLADES ON HER FEET OR EVEN HAVING SHURIKEN IN HER ARSENAL. OTHER TIMES, THE VISUAL CUES CAN BE MORE SUBTLE AND SYMBOLIC, SUCH AS MAKING HER AFRO SHURIKEN SHAPED.

BE CREATIVE AND ORIGINAL WHILE HAVING FUN WITH YOUR DESIGNS.

WITH FRANKIE, SINCE NINJAS TEND TO BE STEALTHY AND BLACK IS A COLOR ASSOCIATED WITH DEATH AND MYSTERY, IT SHOULD MAKE SENSE THAT HER PRIMARY COLOR IS BLACK. NINJAS HAVE ALSO HISTORICALLY WORN BLACK TO CONCEAL THEIR PRESENCE IN THE DARK, MAKING BLACK AN EASY CHOICE FOR CYMONE.

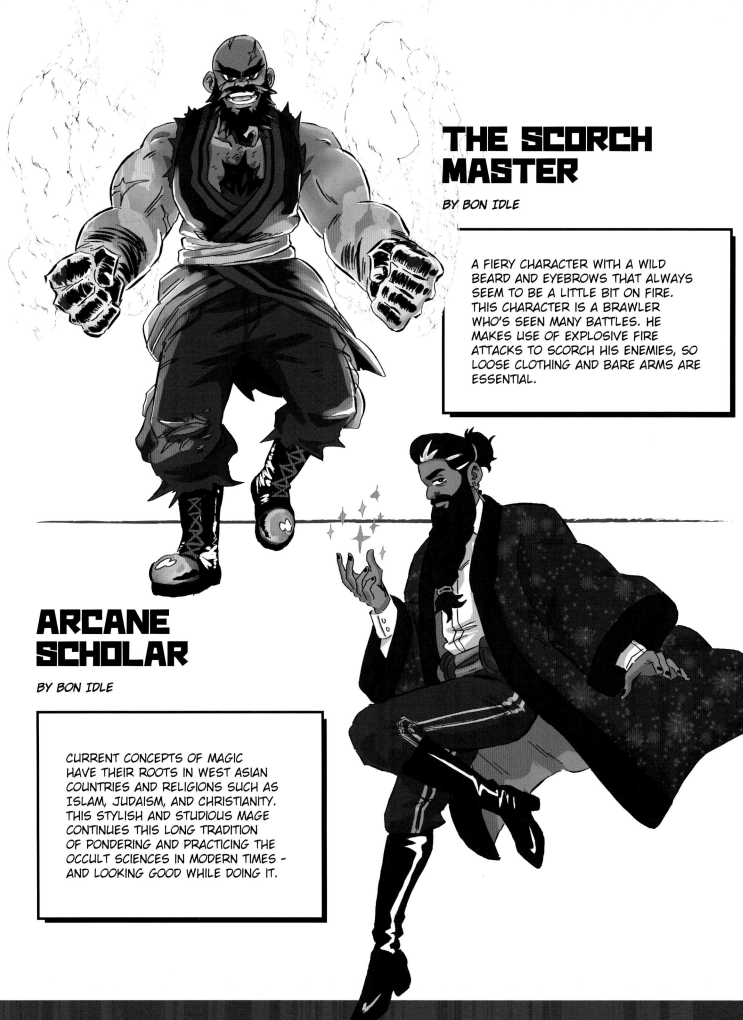

THE SCORCH MASTER

BY BON IDLE

A FIERY CHARACTER WITH A WILD BEARD AND EYEBROWS THAT ALWAYS SEEM TO BE A LITTLE BIT ON FIRE. THIS CHARACTER IS A BRAWLER WHO'S SEEN MANY BATTLES. HE MAKES USE OF EXPLOSIVE FIRE ATTACKS TO SCORCH HIS ENEMIES, SO LOOSE CLOTHING AND BARE ARMS ARE ESSENTIAL.

ARCANE SCHOLAR

BY BON IDLE

CURRENT CONCEPTS OF MAGIC HAVE THEIR ROOTS IN WEST ASIAN COUNTRIES AND RELIGIONS SUCH AS ISLAM, JUDAISM, AND CHRISTIANITY. THIS STYLISH AND STUDIOUS MAGE CONTINUES THIS LONG TRADITION OF PONDERING AND PRACTICING THE OCCULT SCIENCES IN MODERN TIMES - AND LOOKING GOOD WHILE DOING IT.

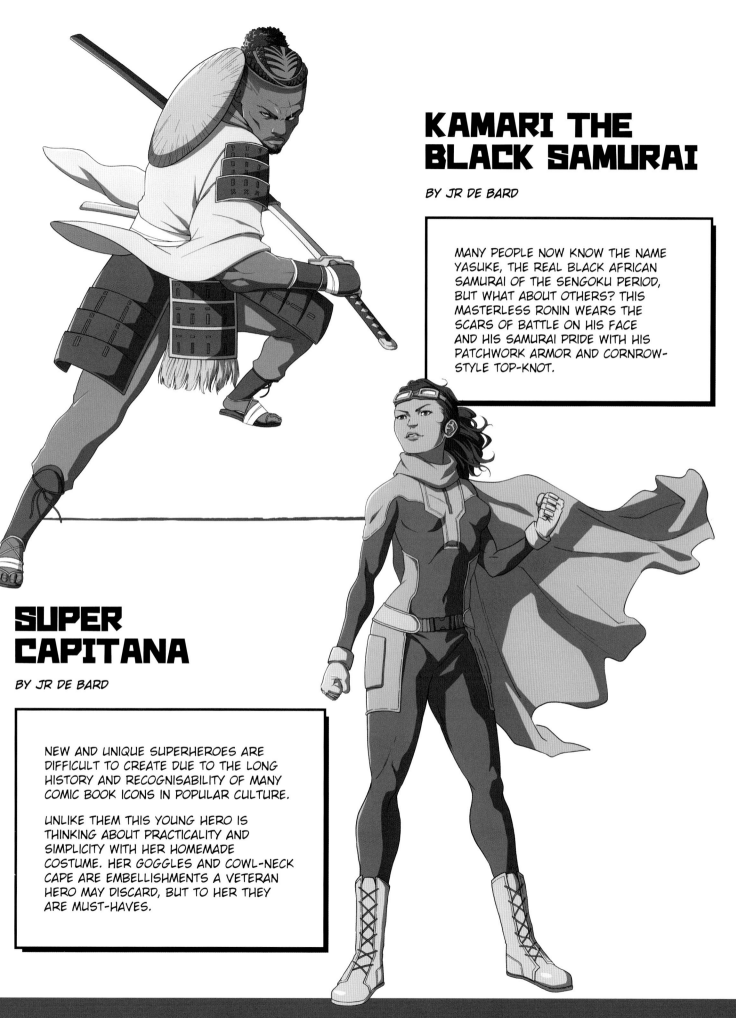

KAMARI THE BLACK SAMURAI

BY JR DE BARD

MANY PEOPLE NOW KNOW THE NAME YASUKE, THE REAL BLACK AFRICAN SAMURAI OF THE SENGOKU PERIOD, BUT WHAT ABOUT OTHERS? THIS MASTERLESS RONIN WEARS THE SCARS OF BATTLE ON HIS FACE AND HIS SAMURAI PRIDE WITH HIS PATCHWORK ARMOR AND CORNROW-STYLE TOP-KNOT.

SUPER CAPITANA

BY JR DE BARD

NEW AND UNIQUE SUPERHEROES ARE DIFFICULT TO CREATE DUE TO THE LONG HISTORY AND RECOGNISABILITY OF MANY COMIC BOOK ICONS IN POPULAR CULTURE.

UNLIKE THEM THIS YOUNG HERO IS THINKING ABOUT PRACTICALITY AND SIMPLICITY WITH HER HOMEMADE COSTUME. HER GOGGLES AND COWL-NECK CAPE ARE EMBELLISHMENTS A VETERAN HERO MAY DISCARD, BUT TO HER THEY ARE MUST-HAVES.

MS. FIXIT

BY VENUS BAMBISA

SHE CAN FIX NEARLY ANYTHING, ALTHOUGH YOU MAY OFTEN FIND HER BREAKING THEM APART FIRST TO FIGURE THEM OUT. THIS CHARACTER IS PRACTICAL WITH HEAVY-DUTY DUNGAREES AND A TOOL BELT, PLUS A BANDANA TO KEEP HER HAIR OUT OF HER FACE SO SHE CAN KEEP BREAKING - SORRY, FIXING THINGS.

LAST OF THE FIRE BORNE

BY VENUS BAMBISA

HE IS THE LAST OF A GROUP OF PEOPLE BORN WITH THE ABILITY TO MANIPULATE FIRE. THE TRIBE BELIEVED THAT THEY RECEIVED THEIR POWERS FROM A GOD THAT LIVES IN THE SUN, SO THIS CHARACTER DESIGN FEATURES LOTS OF SUN ICONOGRAPHY AND SYMBOLISM WITHIN IT, ALONG WITH MAGIC-USER STAPLES SUCH AS LOTS OF BELTS, POUCHES, AND A BOOK OF MAGIC.

KAWAII EXPLORER

BY VENUS BAMBISA

THERE IS NOTHING MORE IMPORTANT TO HER THAN THE JOURNEY, EVEN IF IT MEANS SOMETIMES GETTING LOST OR EXPLORING NEW PATHWAYS.

WITH HER TRUSTY RUCKSACK AND SLEEPING MAT ON HER BACK AND HER HIKING BOOTS ON HER FEET, SHE'S READY TO STEP INTO THE NEXT ADVENTURE.

GOD-HAMMER WARRIOR

BY VENUS BAMBISA

LEGEND SAYS THAT THE MONKEY KING TOOK IN AND TRAINED SEVEN TEENS BEFORE HE DIED TO PREPARE THEM FOR A FUTURE WAR BETWEEN THE GODS THAT WOULD SPELL THE END OF THE WORLD. EACH WAS GIFTED POWER AND A WEAPON MADE OF THE SAME MATERIAL AS HIS STAFF.

THIS CHARACTER RECIEVED THIS GOD-HAMMER, SO THEIR LIGHT, BREEZY OUTFIT ALLOWS THEM TO MOVE FREELY, SWING WIDE, AND BRING THE HAMMER DOWN.

KATANA PUNK

BY VENUS BAMBISA

SHE IS A MERCENARY, PROBABLY ONE OF VERY FEW MERCENARIES THAT USES A MELEE WEAPON AS OPPOSED TO A TYPICAL SNIPER RIFLE OR ANY OTHER LONG RANGE WEAPON. DESPITE USING A KATANA, SHE BOASTS THE HIGHEST KILL COUNT AND A NEAR PERFECT SUCCESS RATE.

MERMAID GIRL

BY VENUS BAMBISA

MANY MERMAID CHARACTERS TEND TO LOOK SIMILAR, SO THIS NON-TRADITIONAL MERMAID FEATURES DARK SKIN WITH AFRO-STYLE BLONDE HAIR AND A VIBRANT PINK TAIL (PLUS A COLOR-MATCHED HAIR BAND).

EARTH-BENDING SERGEANT

BY VENUS BAMBISA

A NO-NONSENSE, SOUTH-AFRICAN OFFICIAL WITH THE POWER TO MOVE THE VERY EARTH. HER NEATLY WORN UNIFORM FEATURES EMBLEMS OF HER ORGANIZATION, SHOWING HER AFFILIATION, AS WELL AS HER RIGID, GROUNDED DEMEANOR.

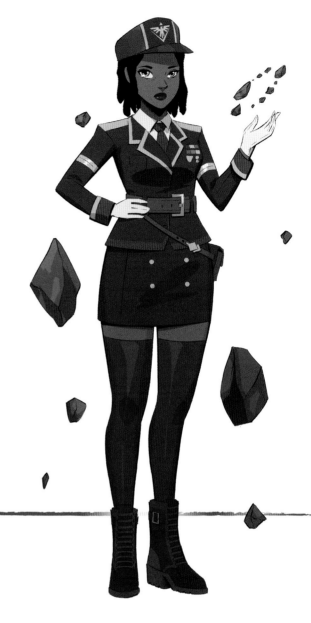

EL JEFE

BY MORGANNE WALKER

THIS MACHO, MOUSTACHIOED MEXICAN MAN MEANS BUSINESS. MIXING CLASSIC VAQUEROS STYLING WITH TRADITIONAL MEXICAN ICONOGRAPHY INTEGRATED INTO THE COSTUME (SUCH AS CALAVERA - SUGAR SKULLS - AND A CATHOLIC ROSARY, THIS CHARACTER DESIGN IS EVOCATIVE OF 70'S MEXICAN B-MOVIES WITH A DISTINCT MANGA FLAIR.

LI MIN, THE DRAGON ARM

BY JEYODIN

BLESSED WITH A MAGICAL TATTOO, THIS POWERFUL WOMAN IS ABLE TO USE HER QUICK JABS AND PUNCHES TO CRUSH NEARLY ANY OPPONENT. THIS DESIGN BRINGS TOGETHER A WRESTLER UNIFORM WITH A FEMALE CURVY FIGURE. THIS CHINESE CHARACTER DESIGN, WHOSE NAME MEANS "QUICK STRENGTH," IS REPRESENTATIVE OF THE SILHOUETTE TEST.

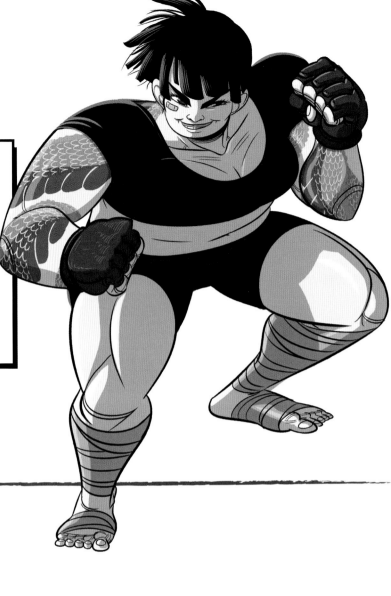

WILLOW

BY WHYT MANGA

WILLOW IS A NINE-YEAR-OLD ADVENTUROUS GIRL WITH VITILIGO. THIS SKIN CONDITION IS SIMILAR TO THAT OF THE SUCCESSFUL MODEL, WINNIE HARLOW, AND IS PURPOSELY DESIGNED TO LOOK LIKE SHE'S FROM THE AFRICAN HOMETOWN OF THE CREATOR, WHYT MANGA. THE CHARACTER'S DESIGN USES A VARIETY OF PHILOSOPHIES INCLUDING COLOR THEORY, SEMIOTICS, AND SHAPE LANGUAGE.

SOLE CAMARA

BY PAP SOULEYE FALL

AN OUT AND PROUD REVOLUTIONARY IN ART AND FASHION, SOLE (NICKNAMED FOR HER SHOES) CAMARA IS A MODERN PROTAGONIST WHO FIGHTS FOR EVERYONE. THE DARK SKIN TONE AND UNIQUE HAIRSTYLE MAKE HER A STRIKING CHARACTER DESIGN FOR FANS OF COOL MANGA CHARACTERS.

CURSED SWORDBEARER

BY BON IDLE

POST-APOCALYPTIC DESERT WASTELANDS CAN BE A HARSH ENVIRONMENT TO GROW UP IN, SO PRACTICAL OUTFITS DESIGNED FOR THE DUNES ARE FUNDAMENTAL... ANCIENT CURSED SWORDS ARE JUST A NICE ACCESSORY.

THIS CHARACTER SPORTS A DARK UNDERSUIT CONTRASTED WITH ALL THREE PRIMARY COLORS (RED, YELLOW, BLUE) INCLUDED INTO THE DESIGN FOR A POP OF COLOR IN A DRAB LANDSCAPE.

PART SIX:

TOOLS & MORE

IT HAS NEVER BEEN EASIER TO CREATE YOUR OWN MANGA-INSPIRED COMIC THAN IT IS TODAY. WHETHER YOU PREFER TO WORK DIGITALLY OR TRADITIONALLY, THE TOOLS YOU WILL NEED ARE AVAILABLE BOTH MORE CONSISTENTLY AND MORE AFFORDABLY TODAY THAN EVER BEFORE. THIS SECTION PROFILES SOME OF THE TOOLS YOU MIGHT USE.

ART TOOLS

THREE FEATURES TYPICALLY HELP YOU CHOOSE THE BEST TOOLS FOR YOU. BY CONSIDERING COST, COMFORT, AND RELIABILITY, YOU WILL FIND ART SUPPLIES THAT WILL HELP YOU ACHIEVE THE TYPE OF QUALITY ILLUSTRATIONS THAT YOU CAN USE TO BUILD A FANBASE.

THERE ARE AS MANY DIFFERENT WAYS TO CREATE ART AS STARS IN THE SKY, BUT HERE ARE SOME GO-TO ART TOOLS TO GET YOU STARTED.

TRADITIONAL

PENCILS

You know what these are. You can't go wrong with a good old HB (hard black) pencil, but if you're planning on inking your sketches, give blue pencils a try—they'll help you see your ink lines much more clearly.

FINELINER PENS

If you want consistent line thickness, you can't go wrong with a fineliner pen. They're available in various tip sizes, so try a few out and find what sizes work for you and your art.

BRUSHES / BRUSH PENS

Use brushes to add dramatic line work, speech bubbles or just to help fill in black areas in your artwork. Brush pens make life even easier.

NIB PENS

This type of pen has a handle with grooves in the end where you can slide in different metal nibs, each with their unique uses, that dip into ink.

The most common nibs used by manga artists are:

SAJI (SPOON) G-PEN NIB MARU

INK

For dipping and spilling (it happens – don't worry about it)!

CORRECTION FLUID

Nobody's perfect. Keep handy to tidy up stray lines and ink drops or to neaten up an edge.

TRADITIONAL

ALCOHOL MARKERS

Brands may vary, but these versatile markers use alcohol-based ink to give semi-opaque, even, quick-drying coverage that can be layered to create even more colors. A staple of color manga art.

RULERS AND EDGES

Essential for drawing perspective guides, backgrounds, panel borders and zoom lines.

FRENCH CURVES

Not essential, but these can be helpful for drawing smooth curves and neat speech bubbles.

SCREENTONES

Thin, semitransparent adhesive sheets you lay on your artwork, trim the edges, and then flatten down. If you want your manga art to feel like manga art, adding screen tone is a surefire way to do it.

SCALPEL / BLADE

Be careful with this one!

Use a thin blade to trim screen tone or artwork to paste onto other sheets.

DIGITAL

COMPUTERS

Can be a desktop, laptop, whatever suits your lifestyle and budget. Just make sure it's powerful enough to run whatever programs you need.

TABLET COMPUTER

Some digital artists don't use a computer at all, they create their work exclusively using a tablet computer and a stylus pen.

GRAPHICS TABLET

Available from several manufacturers, graphics tablets function similar to a typical computer mouse, but you use a pen instead. These can vary from smaller, budget-friendly tablets to large, full-color screen-based tablets with all the bells and whistles that the pros use.

DRAWING / ART SOFTWARE

There are lots of different art programs available. Some require a one-off cost, some are subscription-based and some are totally free. Check out reviews or try a few out to figure out what suits your workflow and budget.

WORK SPACES

EVERY ARTIST PRODUCES THEIR ART WITHIN AN ENVIRONMENT AT THEIR HOME OR A PRIVATE OFFICE OR STUDIO. FORTUNATELY, THERE IS NO MANDATORY SETUP THAT EVERYONE HAS TO FOLLOW. SINCE NO TWO ARTISTS ARE ALIKE, WE'VE COMPILED UNIQUE EXAMPLES FROM THREE OF SATURDAY AM'S MOST PROLIFIC CREATORS TO SHOW HOW THEY CREATE THEIR MANGA-INSPIRED COMICS.

RAYMOND BROWN

CREATOR OF *BULLY EATER*

RAYMOND BROWN, THE CREATOR OF SATURDAY AM'S LONG-RUNNING SERIES BULLY EATER, SHOWS THAT IT'S POSSIBLE TO CREATE MANGA EVEN WHILE BEING A BUSY DAD. AS ONE COULD IMAGINE, WORKING A FULL-TIME JOB AND RAISING THREE YOUNG CHILDREN DOESN'T LEAVE TIME FOR MUCH ELSE, ESPECIALLY CREATING MANGA. FOR CREATORS LIKE RAYMOND, PROPER TIME MANAGEMENT SKILLS ARE VITAL, BUT HIS CHOICE OF TOOLS IS JUST AS IMPORTANT.

Up until recently, Raymond used traditional art supplies to create his work. However, due to cost and storage limitations, he now prefers to work digitally when creating his comics. Though switching to digital can be a costly up-front investment (purchasing computer equipment, software, etc.), the long-term time and money savings are immense.

Raymond uses a second-generation Bamboo Ink smart stylus with a 12-inch Microsoft Surface Pro 3 (Intel Core i5, 8 GB RAM, 256 GB storage). Drawing for long periods can cause the Microsoft Surface's screen to get very hot, so we suggest using a cooling pad—like Raymond's Targus Chill Mat—to keep the screen comfortable to draw on.

"WORKING 100 PERCENT DIGITALLY NOT ONLY SAVES TIME AND MONEY, BUT IT ALSO GIVES ME ACCESS TO TOOLS THAT WOULD BE DIFFICULT TO GET PHYSICALLY."

RAYMOND BROWN,
BULLY EATER CREATOR

WORK SPACE

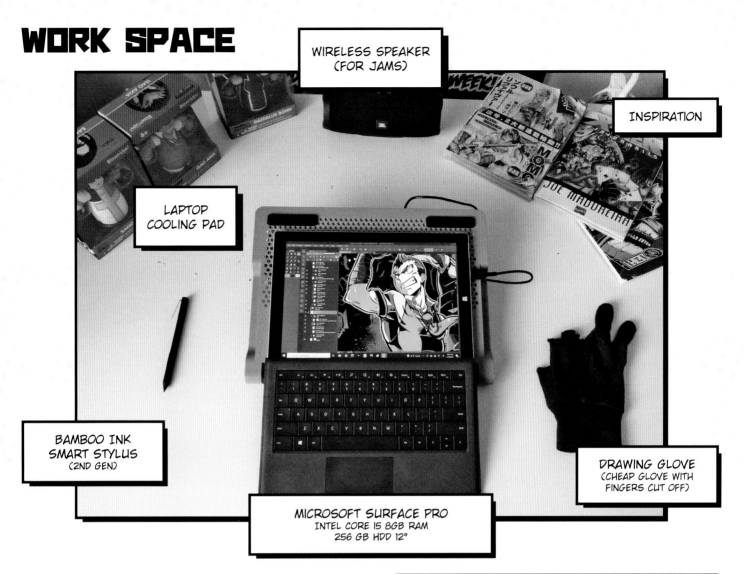

WIRELESS SPEAKER
(FOR JAMS)

INSPIRATION

LAPTOP
COOLING PAD

BAMBOO INK
SMART STYLUS
(2ND GEN)

DRAWING GLOVE
(CHEAP GLOVE WITH
FINGERS CUT OFF)

MICROSOFT SURFACE PRO
INTEL CORE I5 8GB RAM
256 GB HDD 12"

HARDWARE

- Microsoft Surface Pro 3 Intel Core i5 8 GB Memory 256 GB 12 inch Screen
- Bamboo Ink Smart Stylus (2nd Gen)
- Targus Chill Mat

Drawing for long periods of time can cause the Microsoft Surface's screen to get very hot. We suggest using a laptop "cooling pad" in order to keep the screen comfortable to draw on.

SOFTWARE

Raymond uses **Clip Studio Paint** and **Adobe Photoshop** as his primary drawing/design softwares.

BON IDLE

CREATOR OF *HENSHIN!*

BON IDLE IS A FULL-TIME GRAPHIC DESIGNER AND ILLUSTRATOR WORKING WITHIN A MARKETING AGENCY IN THE UK FOR CLIENTS IN VARIOUS INDUSTRIES. HIS JOB TAKES UP MUCH OF HIS TIME, SO CREATING HIS SATURDAY BRUNCH SERIES, HENSHIN!, FALLS TO EVENINGS AND WEEKENDS. BEING EFFICIENT WITH HIS TIME IS CRITICAL FOR HIM.

Digital art has many benefits. For Bon Idle, it is the speed and ability to quickly iterate and refine using layers as well as options such as cutting, moving, skewing, and warping parts of an image. Being able to reference photography on the screen directly and use 3D models and the perspective guide tools in Clip Studio Paint are other positive additions to his workflow.

Aside from sketchbook or scratch-paper illustrations on the go, Bon Idle draws most of his art digitally using an iPad Pro (and a helpful draftsman table–style iPad stand) with finishing touches done using Adobe Photoshop or Adobe InDesign. The Apple Pencil is an intuitive and powerful accessory for many models of the iPad, allowing people to create high-quality art either on the go or in the comfort of their office or home.

WORK SPACE

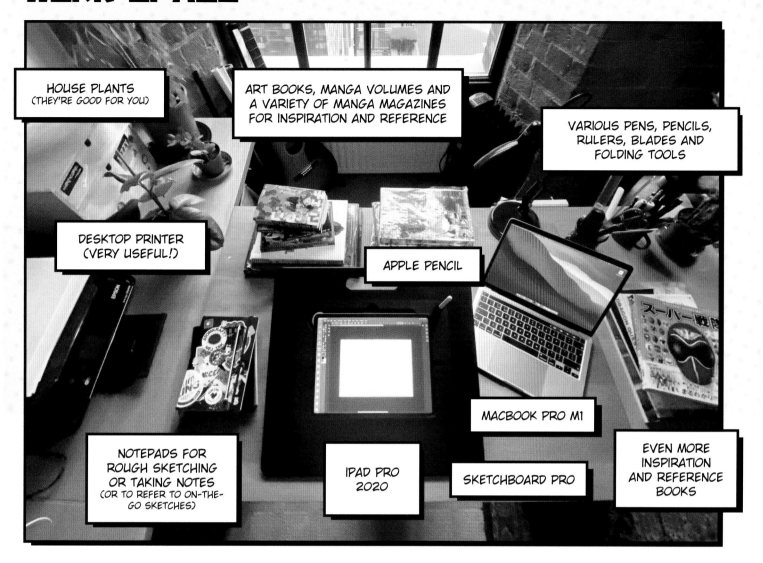

HOUSE PLANTS
(THEY'RE GOOD FOR YOU)

ART BOOKS, MANGA VOLUMES AND A VARIETY OF MANGA MAGAZINES FOR INSPIRATION AND REFERENCE

VARIOUS PENS, PENCILS, RULERS, BLADES AND FOLDING TOOLS

DESKTOP PRINTER (VERY USEFUL!)

APPLE PENCIL

MACBOOK PRO M1

NOTEPADS FOR ROUGH SKETCHING OR TAKING NOTES (OR TO REFER TO ON-THE-GO SKETCHES)

IPAD PRO 2020

SKETCHBOARD PRO

EVEN MORE INSPIRATION AND REFERENCE BOOKS

HARDWARE

- Apple iPad Pro 2020
- Apple pencil (Generation 2)
- Apple MacBook Pro 2021
- Sketchboard Pro

SOFTWARE

Bon Idle uses Procreate for iPad mainly for thumbnail sketches and rough art, but then switches to Clip Studio Paint Ex for creating his comic pages, including "pencils", "inks" and screentones. He finishes the pages in Adobe InDesign (a page layout and design program) to arrange the pages and add dialogue to speech bubbles.

> "I'M SUPER IMPATIENT, BUT I'M ALSO LAZY AND A PERFECTIONIST, WHICH IS A DIFFICULT COMBINATION. DRAWING ARTWORK DIGITALLY USING A DEVICE LIKE AN IPAD MEANS I CAN ITERATE AND REFINE MY ART QUICKLY AND TAKE ADVANTAGE OF TOOLS SUCH AS 3D MODELS."
>
> BON IDLE,
> HENSHIN! CREATOR

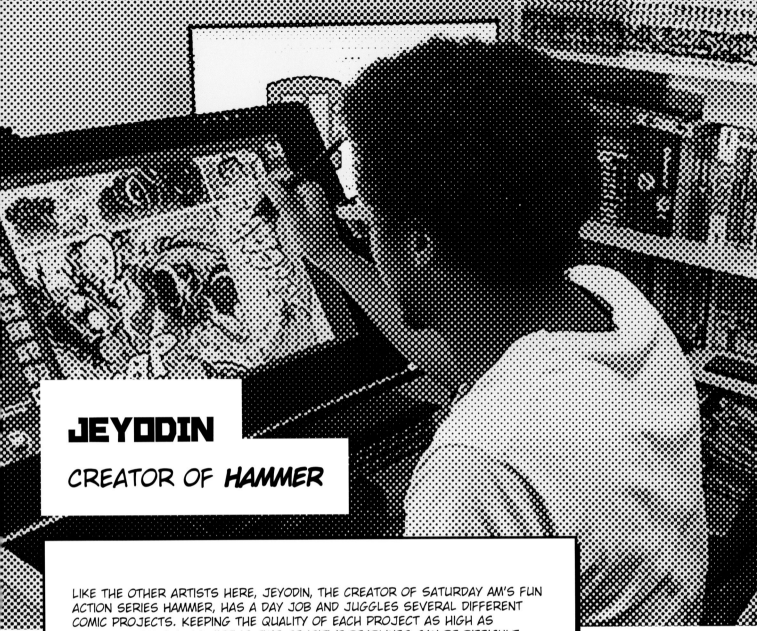

JEYODIN
CREATOR OF *HAMMER*

LIKE THE OTHER ARTISTS HERE, JEYODIN, THE CREATOR OF SATURDAY AM'S FUN ACTION SERIES HAMMER, HAS A DAY JOB AND JUGGLES SEVERAL DIFFERENT COMIC PROJECTS. KEEPING THE QUALITY OF EACH PROJECT AS HIGH AS POSSIBLE WHILE ALSO HITTING TIME-SENSITIVE DEADLINES CAN BE DIFFICULT. LUCKILY, HAVING THE RIGHT TOOLS AND INSPIRATION HAS HELPED HIM SUCCEED IN MEETING THOSE GOALS. HERE'S A SNEAK PEEK INTO JEYODIN'S HOME OFFICE.

JeyOdin has been using tablets and digital art programs since he was in high school. As mentioned, the initial cost of these items can vary depending on which brand or size of the tablet bought, but you wind up spending a lot less money in the long run. Yes, free-standing drawing tablets can be a few hundred or even thousands of dollars, but the cost of constantly replenishing paper, pens, nibs, and erasers reduces to ZERO.

Today, JeyOdin uses the Wacom Cintiq Pro 24 and Clip Studio Paint Pro to create HAMMER for Saturday AM.

> **"I LOVE DRAWING TRADITIONALLY, BUT DRAWING COMICS DIGITALLY IS DEFINITELY EASIER."**
>
> JEYODIN,
> HAMMER CREATOR

WORK SPACE

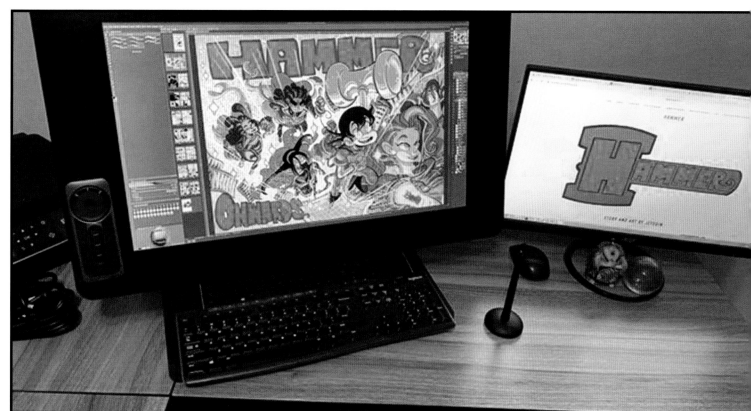

EXTRAS

GLOSSARY

ANIME

In Japan, anime refers to animation of all kinds. Outside Japan, it has traditionally referred to animation created in Japan or by Japanese creators, but it has also come to mean any animation that follows Japanese aesthetic and/or genre conventions.

BLAXSPLOITATION

A genre of media originating in American films of the 1970s featuring prominent Black characters and designed to appeal to Black audiences. Although the original blaxploitation films were often created by white directors and producers and criticized for their perpetuation of stereotypes, the genre has also been reclaimed and reimagined by Black creators.

COMICS

The broad category of art that includes manga and generally involves a series of illustration panels set sequentially and combined with text elements such as speech balloons, captions, sound effects, and more.

FANSERVICE

Elements in anime and manga included for the sole purpose of pleasing viewers or readers. This most often, though not always, involves sexual content—most often revolving around female characters.

GRAPHIC NOVEL

A book-length work of comic art telling a self-contained story. This term is generally used to distinguish a work from a comic book, which is more often a single issue or collection of single issues, though the terms are sometimes used interchangeably, and the line between them isn't always definite.

HATCHING

A shading technique that uses closely set parallel lines to show depth and shadow. When layers of hatching at different angles are placed on top of each other, this is called crosshatching.

JOSEI

A genre of manga marketed toward older teen girls and adult women.

KAIJU

Giant monsters, or the genre of media that features them.

MANGA

Like anime, manga originally referred to Japanese comics and graphic novels but is now also used to describe comics that follow the Japanese style.

MANGA-KA

The Japanese term for a manga artist.

SCANLATION

Manga that fans have scanned and translated themselves, generally without permission from the publisher.

SEINEN

A genre of manga targeted toward older teen boys and adult men.

SEMIOTICS

The study of signs or sign processes and how intentional or unintentional imagery can add meaning to artwork.

SHAPE LANGUAGE

The use of basic shapes—such as circles, squares, and triangles—within the design of a character to evoke certain meanings or attitudes.

SHOJO

A genre of manga targeted toward preteen and teen girls.

SHONEN

A genre of manga marketed toward preteen and teen boys.

SILHOUETTE TEST

A way to determine whether a character is distinctive and recognizable. If a reader can identify a character from their silhouette alone, that character passes the silhouette test.

STIPPLING

A shading technique that uses small dots to show depth and shadow. The more densely the dots are placed in a given area, the darker that area will appear.

ZOOM LINES

Lines radiating out from a central point to create an effect of zooming in on or emphasizing an element on the page.

ACKNOWLEDGMENTS

WHEW!

This book was BOTH an experience and an accomplishment!

There is not enough space to thank everyone who has championed our efforts, but I'd like to name a few groups:

FAMILIES

Our parents, siblings, spouses, children, and even pets were fantastic! Creating art is always made easier by the support of our loved ones.

ROCKPORT PUBLISHERS / THE QUARTO GROUP

We could not have selected better partners for our first tutorial book as well as our graphic novel program (please check them out as well)!

SATURDAY AM / MYFUTPRINT ENTERTAINMENT, LLC

The teams (i.e., artists, staff, and volunteers) behind our company are literally our secret weapon. It's impossible to champion diversity when you don't work with interesting and talented people that you consider family regardless of their backgrounds.

YOU, THE FAN!

Simply put, ALL OF US LOVE MANGA! Your support in our efforts to bring more inclusion to the artform is EVERYTHING!

While this book only scratches the surface of everything we want to do, we trust that if you enjoy it and tell your friends and fellow artists, we can continue the series.

Thanks again!

—Frederick L. Jones, Saturday AM Publisher

CREDITS

THE TEAM

FREDERICK L. JONES

Frederick L. Jones is a former video-game executive with stints at Rapp Collins Worldwide and the former Blockbuster. He founded MyFutprint Entertainment LLC in 2013 as a means to bring more diversity to manga and has created several brands and series for the firm, including SATURDAY AM, CLOCK STRIKER, MASSIVELY MULTIPLAYER WORLD OF GHOSTS, and MARCH ART MADNESS.

RAYMOND BROWN

Raymond Brown is an illustrator and graphic designer from Wilmington, North Carolina. A graduate of the Art Institute of Charlotte, he is also a cofounder of MyFutprint Entertainment LLC. He is the creator of the long-running manga-inspired Saturday AM comic series BULLY EATER.

ODUNZE OGUGUO

Odunze Oguguo, known as Whyt Manga, is a cofounder of MyFutprint Entertainment LLC and creator of the hit series APPLE BLACK and BACASSI, published in Saturday AM and Saturday PM, respectively.

JR DE BARD

JR De Bard, known as JRamaManga, is an illustrator based in New York. He graduated from Binghamton University with a bachelor's in graphic design and is the creator of the popular Saturday PM series UNDERGROUND.

MITCH PROCTOR

Mitch Proctor, known as Bon Idle, is a graphic designer and illustrator from Nottingham, England, where they live with their cat. They are also the creator of the Sentai-inspired comic HENSHIN! for Saturday BRUNCH.

JONATHAN MULLINS

Jonathan Mullins, known as JeyOdin, is the creator of Saturday AM's popular series HAMMER. The prolific artist from New Orleans has been published by Antarctic Press, Oni Press, and USA TODAY. He lives with his wife and two cute (and often hilarious) dogs.

OSCAR FONG

Oscar Fong, known online as @fongfumaster, is a New Zealand–based freelance illustrator. He is a cocreator and artist of the popular manga-inspired Saturday AM series MASSIVELY MULTIPLAYER WORLD OF GHOSTS.

CONTRIBUTORS

MORGANNE WALKER

Morganne Walker, known online as @soulbeatmanga, lives in Indianapolis and is a Ball State University alumna with a master's in architecture. She currently works full-time as a graduate architect while also creating her popular Saturday AM series, SOUL BEAT.

VENUS BAMBISA

Venus Bambisa is a South African–born freelance concept artist and Illustrator. He is the creator of the manga-inspired comic title REVOLVER KISS at Saturday PM.

ISSAKA GALADIMA

Issaka Galadima, known online as @gladiskstudio, is from the Niger Republic and currently lives in France, where he works as a mobile app developer. He is the artist of the hit series CLOCK STRIKER for Saturday AM.

ANDREA DONEY

Andrea Otilia Doney is known as Seny to her friends and online as @saigamiproject. She is a lesbian comic artist from Hungary and is the creator of both SAIGAMI in Saturday AM and KILLSHOT in Saturday BRUNCH.

PAP SOULEYE FALL

Pap Souleye Fall is a Senegalese-American artist who lives and works in Dakar, Senegal. He is currently in the Yale University sculpture program finishing his Master's degree. Papsouleye's love for storytelling and visual art led him to create his own story, OBLIVION ROUGE.

FRED TORNAGER

Fred Tornager, known online as @fred_tornager, is a Danish manga artist and creator of the new Saturday BRUNCH manga-inspired title GUNHILD.

RESOURCES

GUESS THE STYLE QUIZ ANSWERS

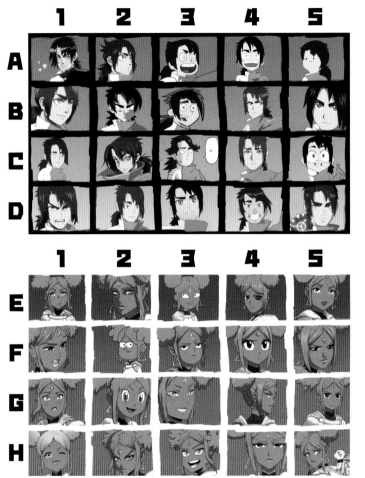

A1. Jojo's Bizarre Adventure

A2. Black Clover

A3. Steven Universe

A4. One Piece

A5. Adventure Time

B1. Attack on Titan

B2. Dragon Ball

B3. Danny Phantom

B4. Bleach

B5. Full Metal Alchemist Brotherhood

C1. Family Guy

C2. Code Gease

C3. One Punch Man

C4. Naruto

C5. Teen Titan Go!

D1. My Hero Academia

D2. Studio Ghibli Style

D3. Devil Man Crybaby

D4. Akira

D5. Apple Black

E1. Soul Eater

E2. Berserk

E3. Rick and Morty

E4. Tokyo Ghoul

E5. Hunter X Hunter

F1. Seven Deadly Sins

F2. Gravity Falls

F3. Mob Psycho 100

F4. Fairy Tail

F5. Death Note

G1. Legend of Korra

G2. Pokémon X and Y

G3. Haikyuu

G4. Gintama

G5. Darling in the Franxx

H1. The Promised Neverland

H2. Dr. Stone

H3. My Hero Academia

H4. Cowboy Bebop

H5. Apple Black

INDEX

A

Afro, 44–45
 curly, 65
 hair part, 50–51
 hair part variety, 52–53
 stylized, 46–47
 waves, 48–49
age differences, 83, 93
alcohol markers, 130
Angel, 105
angry faces, 31
anime
 "Black" characters in, 7, 8
 popularity of, 4, 8
anime eyes, 26–29
Apple Black, 5, 42
Arcane Scholar, 120
arms, 86
Ayumi, 89

B

Bacassi, 102
Baji Keisuke, 72
bald and balding, 55–57
Bambisi, Venus, characters of, 122–25
bangs, 70–71
beards
 full, 66, 68–69
 gradated, 68–69
Black hair, 65
Black noses and mouths, 24–25
Black skin tones, 102
Blaze, 110
body, 80–81
 constructing, 84–87
 diverse body types, 88–93
 feet, 95, 96
 hands, 94, 96
 proportions, by age group, 82–83
Bon Idle
 characters of, 110–11, 120, 127
 work space of, 134–35
braids, 58–59
 detailed, 60–61
Brown, Raymond, 54
 work space of, 132–33
brushes/brush pens, 129
Bully Eater, 132
buns
 freeform, 77
 multiple, 76
 single, 74–75

C

Cast, 37, 104
character design
 new characters, 116–27
 Saturday AM characters, 104–15
 theory, 97
 semiotics, 98–99
 shape language, 100
 silhouette test, 101
 skin tones, 102
circular shapes, 100
Claudia Grant (née Claudia Lasalle), 7
Clock Striker, 5, 37, 102, 104
color theory, 102
computers, 131, 133, 135, 136
correction fluid, 129
costume design, importance of, 99
crosshatching
 facial features, 16
 lips, 20
curly Afro, 65
Cursed Swordbearer, 127
curvy body types, 91

D

Daedalus Bonn, 113
Dante Alfonse, 98–99
De Bard, JR, 25
 characters of, 121
detailed braids, 60–61
Detective Dan, 24
Dia Rao, 114–15
"Disco Dante," 98
diverse body types
 age-related, 93
 curvy, 91
 female, 88–89
 muscular, 92
 skinny, 90
diversity in manga, 5, 6–9
Doney, Andrea Otilia, 88
dreadlocks, 62–64, 65
dynamic expressions
 from higher angle, 41
 from lower angle, 38–40

E

ears
 aging and, 93
 drawing, 13
 in dynamic expression, 39
 in 3/4 view, 36, 37
Earth-Bending Sergeant, 125
edges, 130
El Jefe, 125
Emese, 88
emotions, facial expressions and, 30–32
eyebrows, 26, 32, 37
 in dynamic expression, 39, 41
eyes
 aging of, 93
 drawing, 13, 14, 15, 16, 26–29
 in dynamic expression, 39, 41
 for expressing emotion, 30, 31, 32
 female, 28
 placement of, 32
 side view of, 34, 35
 3/4 view of, 36, 37

F

face. *See* head and face features
facial expressions
 capturing personality, 37
 showing emotions, 30–32
facial feature placement, 32
facial hair, 66
 full beards, 66, 68–69
 goatee, 66, 67
 gradated beards, 68–69
 stubble, 67
feet, 86, 95, 96
female characters, 28, 88–89
fineliner pens, 129
Fong, Oscar, characters of, 112–15
Frankie the Cyber Ninja, 118–19
freeform buns, 77
French curves, 130
full baldness, 55
full beards, 66, 68–69

G

Galadima, Issaka, 102
 characters of, 37, 104–5
Gladiskstudio, 5
goatees, 66, 67
God-Hammer Warrior, 123
gradated beards, 68–69
graphics tablet, 131
Guess the Style Quiz, 42
 answers, 141
Gunhild, 106–7

H

hair, facial. *See* facial hair
hairstyles, 43
 Afro, 44–45
 curly, 65
 hair part, 50–51
 hair part variety, 52–53
 stylized Afro, 46–47
 waves, 48–49
 bald and balding, 55–57
 braids, 58–59
 detailed braids, 60–61
 dreadlocks, 62–64, 65
 part gallery, 54
 straight hair
 bangs, 70–71
 buns, 74–77
 long, 72–73
 two-block, 78–79, 117
 tips on Black hair, 65
Hammer, 24, 100, 136
hands, 86, 94, 96
happy faces, 30
hatching
 hair part, 53
 lips, 25
 noses, 22, 23, 25
head and face features, 12
 in aging process, 93
 anime eyes, 26–27
 Black nose and mouth, 24–25
 dynamic expressions, 38–40
 facial expressions, 30–32
 female, 28
 head shape, 13–17, 85
 lips, 18–20
 nose, 21–23
 placement of, 32
 side view of, 33–35
 3/4 view of, 36–37
head size to body height ratio, 83
Henshin!, 110, 134

I

ink, 129
Inoue, Takehiko, 13
Ino Yamanaka, 72

J

Jakari, 104
Japanese manga
 female characters in, 7, 88
 hair in, 54, 55, 66, 70, 72
 lack of diversity in, 7–8
 popularity of, 4, 8
jaw, 13, 28, 30, 33
 age differences and, 93
 in dynamic expression, 40, 41
JeyOdin
 character of, 126
 on drawing Black noses and
 mouths, 24
 shapes used by, 100
 on tips for Black hair, 65
 work space of, 136–37
Jun-Seo the K-Hype Beast, 116–17

K

Kamari the Black Samurai, 121
Karim, 25
Katana Punk, 124
Kawaii Explorer, 123
Killshot, 88
Kishimoto, Masashi, 37

L

Last of the Fire Borne, 122
legs, 86
Li Min, the Dragon Arm, 126
lips, 14, 16, 18–20
 Black, 24, 25
 female, 28
locs. *See* dreadlocks
Loki, 109
long straight hair, 72–73

M

manga. *See also* Japanese
 manga
 diversity in, 5, 6–9
 popularity of, 4, 8
 seinen, 13, 15, 17, 66
*Massively Multiplayer World of
 Ghosts*, 112, 114
Mermaid Girl, 124
mouth
 Black, 24, 25
 in dynamic expression, 39
 for expressing emotion, 30,
 31, 32
 placement of, 32
 side view of, 34, 35
 3/4 view of, 36, 37
Ms. Fixit, 122
multiple buns, 76
Murata, Yusuke, 55
muscular body types, 92

N

Naruto, 37, 72
neck, 28, 36, 39, 56, 92
nib pens, 129
Nilay Rao, 112–13
noses
 Black, 24, 25
 drawing, 14, 16, 21–23
 in dynamic expression, 39, 41
 placement of, 32
 side view of, 34, 35
 3/4 view of, 36, 37

O

Oblivion Rouge, 54, 102
Omen, 111
ONE, 55
One-Punch Man, 55
Opal Wantmore, 42

P

pencils, 129
personality, capturing, 37

R

racial and ethnic insensitivity,
 avoiding, 18, 24
"Real Dante," 99
Reva, 104
Robotech, 6–7
rulers, 130

S

sad faces, 31
Saigami, 5, 89
Sano Bengote Tamashii, 42
Saturday AM
 about, 4–5
 diverse manga and, 5, 8, 9
Saturday Brunch, 5, 106, 110, 134
Saturday PM, 5
scalpel/blade, 130
scar, 15
Scorch Master, The, 120
screentones, 130
seinen manga, 13, 15, 17, 66
semiotics, 98–99
Seny Mangaworks, 5
shape language, 100
Shikamaru Nara, 37
side view of face, 33–35
silhouette test, 101
single buns, 74–75
skinny body types, 90
skin tones, 102
software, 131, 133, 135, 136
Sole Camara, 127
Soul Beat, 98, 99
Souleye Fall, Pap, 54, 102, 127
square shapes, 100
Steel Tusk Durga, 115
stereotypes, avoiding, 21, 54, 99,
 102
straight hair
 bangs, 70–71
 buns, 74–77
 long, 72–73
 two-block, 78–79
Strikers, 104–5
stubble, 67
Stud, 24, 100
stylized Afro, 46–47
Super Capitana, 121

T

tablet computer, 131, 135
teeth, 30, 39, 93
The Scorch Master, 120
Thor, 108
3/4 view of face, 36–37
Tokyo Revengers, 54, 72
tools, 128–29
 digital, 131
 traditional, 129–30
Tornager, Fred, characters of,
 106–9
"Tough Dante," 98
triangular shapes, 100
two-block hairstyle, 78–79, 117

U

Underground, 25
Urasawa, Naoki, 13

V

Vyper Neo, 113

W

Wakui, Ken, 54
Walker, Morganne, 98, 99, 125
waves, Afro, 48–49
Whyt Manga, 5
 characters of, 42, 102, 116–19,
 126
Willow, 126
work spaces, 131
 of Bon Idle, 134–35
 of JeyOdin, 136–37
 of Raymond Brown, 132–33
wrinkle lines, 31, 93

Brimming with creative inspiration, how-to projects, and useful information to enrich your everyday life, quarto.com is a favorite destination for those pursuing their interests and passions.

First published in 2022 by Rockport Publishers, an imprint of The Quarto Group, 100 Cummings Center, Suite 265-D, Beverly, MA 01915, USA.
T (978) 282-9590 F (978) 283-2742 Quarto.com

Rockport Publishers titles are also available at discount for retail, wholesale, promotional, and bulk purchase. For details, contact the Special Sales Manager by email at specialsales@quarto.com or by mail at The Quarto Group, Attn: Special Sales Manager, 100 Cummings Center, Suite 265-D, Beverly, MA 01915, USA.

10 9 8 7 6 5 4 3 2

ISBN: 978-0-76037-542-6

Digital edition published in 2022
eISBN: 978-0-76037-543-3

Library of Congress Cataloging-in-Publication Data available.

Editor: Frederick I. Jones

Design and Page Layout: Mitch Proctor

Cover Image: Odunze Oguguo, Issaka Galadima, Jonathan Mullins, JR De Bard, Oscar Fong, Morganne Walker, Mitch Proctor, Raymond Brown, Fred Tornager
Photography: Raymond Brown, Jonathan Mullins, Mitch Proctor

Illustration: Odunze Oguguo, Issaka Galadima, Jonathan Mullins, JR De Bard, Oscar Fong, Morganne Walker, Mitch Proctor, Raymond Brown, Fred Tornager, Venus Bambisa, Pap Souleye Fall, Andrea "Seny" Doney, Huzayfa 'Zayf' Umar, Goeffrey Jean Louis, Genji Otori

Text: Frederick L. Jones, Odunze Oguguo, Jonathan Mullins, JR De Bard, Oscar Fong, Morganne Walker, Issaka Galadima, Mitch Proctor, Andrea "Seny" Doney

Printed in USA